HIDDEN
HISTORY
of
MARITIME
NEW JERSEY

HIDDEN HISTORY

HISTORY

of

MARITIME
NEW JERSEY

Stephen D. Nagiewicz

THE
History
PRESS

Published by The History Press
Charleston, SC
www.historypress.net

Copyright © 2016 by Stephen D. Nagiewicz
All rights reserved

First published 2016

Manufactured in the United States

ISBN 978.1.46711.829.3

Library of Congress Control Number: 2015959414

Those who went out on sea in ships, they were merchants on mighty waters. They saw the works of the Lord and his wonderful deeds in the deep.

—Psalms 107:23–24

I am dedicating this, my first book, to my wife, Barbara, and son, Travis, who have supported and tolerated my eccentricities while writing and diving over the years. I love you both.

CONTENTS

FOREWORD

New Jersey's near-shore waters are littered with over three thousand shipwrecks, making them a haven for shipwreck divers and enthusiasts like Captain Steve Nagiewicz. For over twenty years, Captain Steve, along with his dive boats, was a shipwreck diving icon on the Jersey shore as divers frequently explored shipwrecks aboard *Diversion I* and *Diversion II*.

Weather permitting, we often started the dive year on January 1. One of my favorite photographs depicts fourteen dry suit–clad New Jersey divers posing on *Diversion I* after a New Year's Day dive on the revenue cutter *Mohawk*. As a customer, colleague and friend, I shared many hours searching for and mapping shipwrecks with Steve.

Steve grew up on the Jersey coast and learned to dive in the late '70s. He very quickly went on to advanced training as a dive master and received his U.S. Coast Guard merchant master's certificate. He has dived on hundreds of shipwrecks, including deep wrecks such as *Andrea Doria*. Over the years, Steve logged more than four thousand dives but not just in New Jersey. His diving career has taken him across the country and the world. He has explored wrecks such as the *Wilkes Barre* in the deep water off Key West and led expeditions to others such as *Bianca C* in Grenada. On any given day, Steve could be found diving on the *Atocha* or searching for wrecks off Bermuda with Teddy Tucker. In addition, Captain Steve carried an Explorer's Club flag for a diving expedition off Greece and also inventoried shipwrecks for the Greek government.

Most recently, Steve was the co-expedition leader on NOAA's mission to map the historic coastal survey vessel *Robert J Walker*. The *Walker* went down after a collision at sea and lies in eighty-five feet of water just ten miles from the towering casinos of Atlantic City. In January 2016, Steve presented results of the project at the Society for Historical Archaeology in Washington, D.C.

Steve has written over seventy-five shipwreck and scuba diving articles, many focused on New Jersey shipwrecks. There is no better person to regale us with the lore of New Jersey's maritime heritage, so sit back and enjoy his New Jersey sea stories.

Vincent J. Capone

Vincent J. Capone is an expert in marine remote sensing who started diving New Jersey shipwrecks as a teenager. He has a master's degree in marine science, has found dozens of shipwrecks, including America's oldest intact warship, the Lake George Radeau, *as well as the* U-215 *off George's Banks. He is the president of Black Laser Learning.*

Acknowledgements

I wish to thank my friends Vince Capone, Dr. James Delgado, Dr. Peter Straub and Dan Lieb for their friendship, their passion for shipwrecks and their advice over the years. A very big thank you goes to my friends who so graciously offered me their photographs that are included in this book: Herb Segars, Larry Cohen and Olga Torry, Amos Nachoum, Richard Galiano, Peter Brink, Dan Lieb, Vince Capone, Pete Straub, Joe Hoyt and Barbara Nagiewicz. Thanks also go out to the staff of Mariners Museum Research Library & Archives in Newport News, Virginia, for their help in researching many of the stories here, as well as to the New Jersey Historical Divers Association located in Wall, New Jersey, and an especially big thanks to Deb Whitcraft and Jim Vogel of the New Jersey Maritime Museum of Beach Haven, New Jersey, for their help and library and for the quick image rescue. I would also like to thank The History Press for this opportunity and the extraordinary advice and patience from my editor Stevie Edwards and former editor Whitney Landis, or this book might not have happened. Thanks also go to my copyeditor Darcy Mahan for her help editing this manuscript; she has made me look more professional as a writer.

Introduction

SHIPWRECK HUNTERS

A ship in port is safe, but that is not what ships are built for.
—Grace Hopper

I have always been a student of history. History is really stories about people and places they inhabit through time. Marine archaeology, sometimes called nautical archaeology or underwater archaeology, is the study of underwater history of shipwrecks, sites and relics all utilized by people. When diving shipwrecks, you cannot help but appreciate the story of how they got there, the people who sailed on these ships and, in many cases, those who died among the many wrecks off the New Jersey Shore. It can sometimes be a reverent experience as you are literally touching a part of history, learning how it came to be there and understanding your role in it. What you will read about in this book are events that happened along the New Jersey coastline that have helped define parts of our maritime heritage, from ten-thousand-year-old Indian settlements to artificial shipwreck reefs and all manner of ship disasters and tragedies in between. Countless stories, articles and books have chronicled shipwreck history before me, and no doubt more will come after this. Enjoy our heritage.

The state is geographically centered between what have arguably been the two busiest seaports on the East Coast of the United States for over 250 years, those two seaports being the Port of New York/New Jersey and Philadelphia/Delaware Bay. Even more so, any ships traversing the East Coast of the United States will, in all likelihood, have to pass

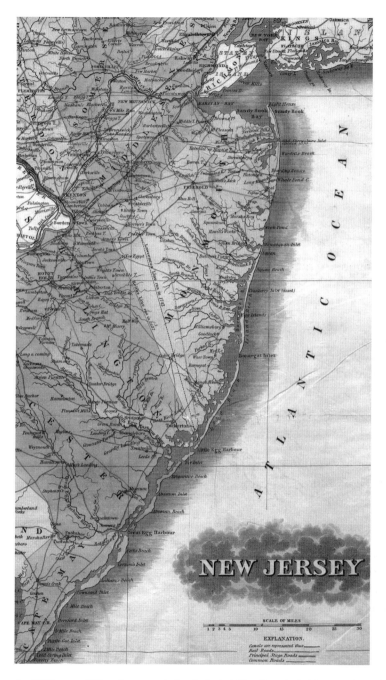

An 1834 map of New Jersey, scaled to include 127 miles of coast along the Atlantic Ocean. *Rutgers University Special Collections (located on the State of New Jersey Official Website).*

along the 127 miles that make up the New Jersey Shore. It has been the reason why New Jersey has remained so economically vibrant as well as secured its prominent place on the historical timeline for 300 years. This is the reason we have a large number of shipwrecks: we have had lots of opportunity to test nature and ourselves. I have been diving the shipwrecks off the New Jersey coast since 1977. I have been fortunate to help identify a few of these wrecks and personally dived many hundreds in over four thousand dives since then, recovering artifacts from many and enjoying the varied marine species that inhabit each site—and catching a few lobsters or fish for dinner!

So how did all these shipwrecks wind up here? Well, those are the mysteries and sea stories you'll read about in this book. The shipwrecks or stories included here have been chosen because of their significant contribution to maritime history, not only for New Jersey but our country as well. When I was asked to write this book on New Jersey's maritime history, I Googled books about New Jersey history, and while I didn't expect the usually obliging Google to give me an exact number of books, what I did get was over 166 million hits! Talk about an intimidating number. I even visited the Official State of New Jersey website to see what it included about maritime matters in its New Jersey state history. I was surprised to find no mention of the state's maritime history. I knew that there was plenty to acknowledge, if for no other reason than that for centuries, much of the products and raw materials used by New Jersey businesses came from places all over the world by ships, and to be fair, there have been many books written about shipwrecks off New Jersey.

Ships are built by people to travel the seas, for commerce, to study the marine environment, to make war or simply for pleasure, whether it be scuba diving, fishing or just for the fun of being on the water. These ships have met their ends in many ways; severe storms took a great toll prior to the mid-1900s. Weather forecasting wasn't as accurate back then.

Forecasting is much better now. It is more accurate and of critical importance that we can learn faster of impending storms, something that was difficult to do in the 1700s through the early 1900s. Sailors back then relied on their own sea experience, observing clouds, winds and waves to be able sense a storm in time to seek safe refuge if they could. Today, seafarers are much safer as a rule because we have satellites constantly looking for such storms to form and vastly more sophisticated scientific technology, computer modeling and better education of how oceans and atmospheres interact and cause both local weather and regional or global climate.

While we got smarter with weather forecasting, we couldn't stop the many wars that took a toll on merchant ships and warships. Nor could we prevent collisions at sea, which were more often caused by human error, bad luck or the lack of proper safety equipment or simply poor maintenance to keep them afloat. Let's not forget the most feared: a fire at sea. If drowning was a horrible way to go, being burned and then drowning was worse.

SHIPWRECK HUNTERS

No one knows the exact number of shipwrecks that are located off the coast of New Jersey, but all agree that number is at least three thousand and likely closer to four thousand—perhaps even more. How do we know about those? The National Oceanic and Atmospheric Administration (NOAA) and its many ocean agencies and departments have scanned the coastal waters of the country for many years. Their sonar and magnetic anomalies or metal detecting technology have identified what are listed as shipwrecks, underwater obstructions. The Office of Coast Survey publishes the Automated Wreck and Obstruction Information System (AWOIS) database. This AWOIS list was primarily designed to look for and mark underwater obstructions in navigable waters. It is used as a guide for commercial fishermen to avoid these underwater obstructions and by divers as a tool to find shipwrecks. The locations don't often match chart locations for reasons not explained but usually having to do with equipment used and the way the surveys use the data.

There are some interesting wrecks with fascinating history and others that are just unique sea stories. Off Asbury Park, for example, you can find, if you know where to look, a tugboat carrying cases of Prohibition whiskey; most of the bottles are still packed in wood crates ready for sale, although after infiltration of seawater for over eighty years, it's all gone bad. Nearby, a private boat was loaded with bales of cannabis (marijuana) that are still lashed to its deck. The losses of both had to cost someone a small fortune many years ago.

I dived an old wood barge in pretty deep water expecting to find lobster, which we did in great numbers, but oddly we also discovered a few handmade ashtray-type casts of sterling silver hidden along the timbers—not worth a whole lot of money but still a fun find! Perhaps it was someone's private stash. Off Sandy Hook in a place labeled the acid dumping grounds, there

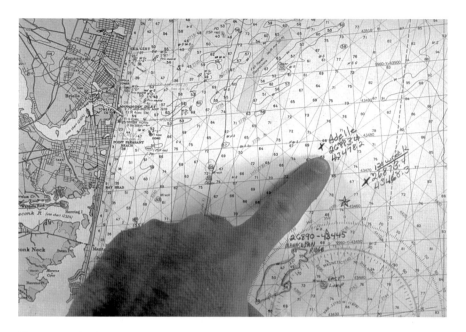

X rarely marks the spot, but it does in this case on the author's chart of various shipwrecks offshore of Manasquan Inlet. *Author's collection.*

are barges of trash from the early 1900s when the practice of dumping trash into the ocean was to pile it aboard an old barge or de-masted schooner and sink it all. (Historical note: when ships changed from sail to steam power, the schooners and sailing ships became obsolete, and many were de-masted, meaning their masts and sails were taken down, and these sailing ships became cargo barges towed behind a steam-powered vessel.) Many of the wrecks off the coast are such sailing ships, useful only for cargo, stripped of their identities and waiting for an explorer to research them or find something that will identify them. It is part puzzle and part mystery to find and identify a clue or clues to a shipwreck's identity. It isn't an easy task, and seldom does "X" mark the spot!

Technology has helped discover and identify many of these shipwrecks in recent years. Many of these wrecks are initially found by commercial fishing vessels and charter boats looking for places to fish that no one knows to gain an advantage for their customers or business. Many are "snags" or "hangs," slang terms for small unidentified obstructions that cause fishing gear to snag or hang up on something underwater that may well be a shipwreck. It could be a whole wreck or just a broken-up piece of wreckage. In a few of these cases, a commercial fishing boat not aware of the possible wreck below

would accidently bring up pieces of a wreck, and in many cases, these pieces of a wreck have helped identify it. But is it usually left for the shipwreck hunters to identify these wrecks.

One of the more famous stories about diving an unknown snag or hang spot is from 1991 when Bill Nagel, former owner and captain of the dive boat *Seeker,* took a group of technical divers to a spot he had heard about in 240 feet (73 meters) of water. They were game to travel over sixty miles offshore to a spot that might turn out to be nothing. Instead, it turned out to a German U-boat submarine—one that shouldn't have been there. That snag turned into a huge historical find due to the patient research and diligence of divers John Chatterton and Richie Kohler who found the artifact that would change the name of this spot from the "U-Who" to its real name, the *U-869.* This whole saga is itself the subject of a few books and will be covered in more detail later in this volume.

Many of these shipwrecks are first scanned using high-tech sonar equipment if you have the budget or friends who have access to one of these. Side-scan sonar equipment has been used by the military and commercial interests for many years, but the equipment was expensive and operators needed to be specially trained not only to set up and use the equipment but also to understand how to correctly read or interpret the data.

Side-scan sonar uses sound waves beamed off transducers located along the sides of a towfish to create an image or picture of the seafloor and, of course, a shipwreck. The hard areas of the seafloor, like sand or rock, reflect more of the sound waves to create a darker or louder image. Objects such as shipwrecks also reflect sound waves, and they cast sonar shadows. The size and shape of the ship can be measured from the sonar shadow it casts. For example, think of the shadows cast by you walking or by buildings, cars or trees on a sunny day. You could look at those shadows to determine what they are and, if you really wanted to, calculate the size of the original object from the length of the shadow it casts. This is oversimplifying the process, but you get the idea.

The sonar image of the tugboat is an example of the sound shadow or sonar image of a shipwreck. The sand, which is a hard area, reflects back as a dark color. The steel hull of the tug is very dark, indicating it is also a hard area, while the whitish shadow to the right of the dark-colored hull indicates the profile of the intact tug and shows its superstructure from bow to stern. Interestingly, you can also see the trough dug by the tug as she slammed into the bottom after being sunk as part of the artificial reef and slid one hundred feet before coming to rest.

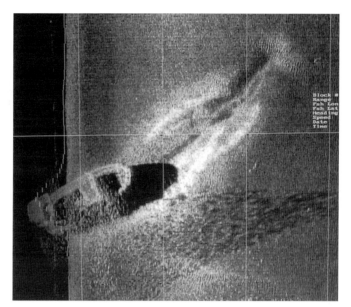

This sonar image shows the outline of a ship on the sandy seafloor sonar shadow. Notice the ditch dug from the impact when she was sunk as part of the artificial reef. *Vince Capone, Black Laser Learning.*

Klein sonar towfish with the author (second from right) and Vince Capone (second from left) of Black Laser Learning, flanked on either side by two of the staff members from the reef program. *Author's collection.*

NOAA's National Ocean Service regularly uses sonar to map the ocean. It notes that in 2001, scientists used side-scan sonar to survey "Shipwreck Alley" in the Thunder Bay National Marine Sanctuary, off the coast of Michigan. So far, the organization only knows about forty shipwrecks in the sanctuary, but there may be more than one hundred.

I also use sonar to look for shipwrecks and use the sonar images to provide information to map those wrecks, as you will read later in this volume. The equipment is more affordable now than it used to be many years ago when I started using a friend's sonar. Of course, "affordable" is a relative term; these side-scan sonar devices are still very expensive. The average price of side-scan sonar ranges from $3,000 to well over $250,000. Using the sonar allows a researcher to cover large areas of ocean much more quickly than using the depth finders that most boats have for navigational use. The sonar can cover several hundred meters at a time, while the relatively simple boat depth sounder looks down in only a few meters of area. An example of such a search would be trying to find your keys on a football field using only a small penlight. You would have to be right over them to find them, but the sonar could cover that entire area in one pass. Both techniques work, but it depends on what you are trying to find and where and how much of a budget you have.

Most shipwrecks up until recently have been found using a ship's depth sounder. In 1963, Martin Klein, who is generally considered to be the "father" of commercial side-scan sonar, helped Harold Edgerton, PhD, use his sonar, along with Alexander McKee, to find Henry VIII's flagship *Mary Rose*. Dr. Edgerton is deeply involved with the development of sonar and deep-sea photography, which was used by Jacques Cousteau in searches for shipwrecks and even the Loch Ness monster. In 2009, Homeland Security published a cost analysis versus performance that confirmed that the L3 Klein Associates System 3900 Sonar ranked the best under typical missions (but not the cheapest at $40,000), which is good to know since that is the sonar I have been able to use over the years with Vince Capone and Stockton University.

The sophistication of sonar improves yearly. Ocean researchers are now using a new type of sonar called multi-beam sonar. Multi-beam systems, like other sonar systems, emit sound waves, but unlike side-scan sonar, which sends sounds waves out laterally from a towed array or towfish, the multi-beam sonar sends the sound waves out in the shape of a fan from directly beneath a ship's hull. These systems measure and record the time it takes for the acoustic (sound) signal to travel from the transmitter (transducer) to

the seafloor (or object) and back to the receiver. Multi-beam sonar produces a "swath" of soundings for broad coverage of a survey area. Both types of sonar can produce three-dimensional images of what lies beneath the surface of the ocean.

New hi-tech ocean mapping devices now include automated underwater vehicles (AUVs) that have sonar high-definition cameras and GPS navigation equipment onboard that survey or map large sections of an area by remote control. Even remotely operated vehicles (ROVs), usually controlled by a tethered cable from a surface ship, can visually see the wrecks and use their own onboard sonar to guide the operator to them. Ocean sonar is very similar to the images produced through sonograms of pregnant women, allowing doctors to get a look at the developing fetus. Police are now using sonar equipment to locate crime scenes in submerged places. The sonar images in this book are the result of wreck surveys that help to determine the dimensions of a wreck so that it can be mapped and later studied. Like a photograph, these sonar images provide a view of that wreck at that time that can be compared to what it looked like before it sank or what it might look like many years after the initial scan, perhaps evidence of the deterioration from sea. Sonar is a valuable tool for shipwreck hunters to be able to see a wreck, gather data and plan dives. It will ultimately be scuba divers who will make the descent to these shipwrecks to look for an artifact that can positively identify the shipwreck and put a name on history.

Chapter *1*

Scuba Diving

Experience Required!

We've looked at remote sensing technology or sonar as a great tool to locate and map shipwrecks remotely. Just as remote sensing technology has improved and become more available and affordable, so, too, have innovations in scuba diving made access easier and safer. As long as ships become shipwrecks, creative and scientifically minded people have found ways to salvage and study them. In the past, cannons, anchors and ship materials were expensive to make, and it was cheaper to go down underwater to salvage them than to replace them. It was not easier but cheaper and quicker, for instance, than ordering the iron cannons from a bog iron furnace in Batsto, New Jersey. That took time to make and even longer to deliver.

Innovation produced results. Long before scuba was invented, men found ways to reach the seafloor. In the illustrated drawing on the following page, showing helmeted divers salvaging a wreck, men from a few hundred years prior recovered salvaged materials from a shipwreck. The idea behind scuba is no different than holding a pail or bucket over your head underwater in a pool and being able to breathe the trapped air inside for a few seconds. The air is trapped by pressure, and the deeper you go, the more pressure compresses the air. You could only take a few breaths this way before you used up the oxygen and replaced it with exhaled carbon dioxide. More than a few of these intrepid pioneers lost their lives or got seriously injured this way, but they were also successful. This concept is what would become part of the science of rebreathers for today's divers and is also used to keep sailors comfortable aboard submarines for long periods of time while submerged.

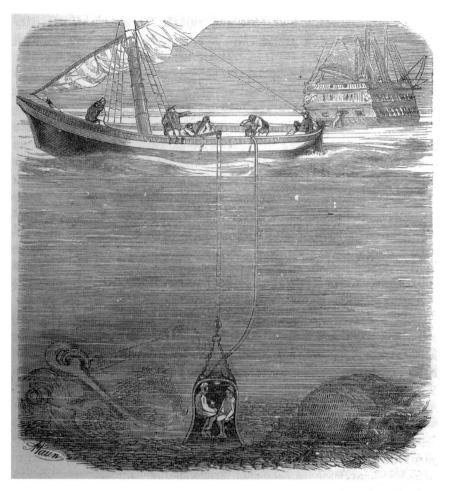

Early wreck salvagers back in the late 1800s are pictured in this drawing, which shows two men in a diving bell. Even two hundred years ago, people were inventive about recovering valuable items. *NOAA.*

In the early 1900s, this passage would fit as a job description for divers written by Rufus Wilson in his book *The Sea Rovers* in 1906:

> *There is something thrilling or perhaps frightening about the occupation of the diver that strongly appeals to the imagination, and with reason, for working fathoms* [one fathom equals six feet of water depth] *below the surface of the water, in semi-darkness, in turbid waters and life-dependent upon a rickety pump for the breath of life, his trade is at best a perilous and precarious one. Perhaps, that is why divers as*

a class are opposed to taking apprentices, and that a majority of the men who drift into the calling do so by accident. Most divers, if you question them, will tell you that the best, if not the only way to acquire their art is to put on a diving suit, go down into the depths, and learn the business for yourself.

Once a wreck is found, it is up to wreck divers to physically dive down on it to see what is there. Diving here in the Northeast is tough. Although there are several beach wrecks in shallow water of twenty-five to thirty feet, most of the wrecks lie in deeper water of seventy feet and much deeper. Ocean water temperatures on the bottom—even in the summer months—can be fifty-five degrees. In the spring, fall and winter, it's not unusual for bottom temperatures to only reach the upper thirties and low forties. It's cold.

If the cold water doesn't deter you, then deep water might. Wrecks here are mostly found in deep water or at least depths where divers have to be concerned with decompression. This limits the amount of time divers can spend on the bottom. At depths under thirty-five feet, the amount of time

New Jersey wreck diving is cold-water diving, often with limited visibility, and is gear intensive. *Author's collection.*

you have to dive is virtually unlimited except by the air you would need to carry in your dive cylinder to be able to breathe. Once you start getting deeper than forty feet, the time allowed to stay on the bottom is governed by physical properties of gases (mostly nitrogen) in your tissues under pressure. As you dive deeper, the water pressure or weight of the water forces the air molecules to compress in your tissues, and those physical properties limit the amount of gas your tissues can absorb at various depths. These gases are nitrogen and oxygen. Recreational dive tables have been developed that govern the maximum amount of time you can spend at various depths, which is based on the theorized absorption rate of these gases under pressure. These tables have been around for a long time and were initially developed by the United States Navy specifically for navy divers. These are referred to as the "No Decompression Dive Tables." If you overstay your time diving, you risk getting into decompression diving, and that requires a higher level of knowledge and experience. The risks start to add up for pushing the limits of what the dive industry calls "recreational diving," which is diving without using any complicated decompression system, although a safety stop at twenty feet for three minutes is always recommended. The risks of avoiding or bypassing safety can be substantial and life threatening. Risks include a sickness called the "bends," which happens when trapped gas bubbles in your tissues expand too quickly as you ascend to the surface rapidly or after staying underwater at depth longer than allowed. Those bubbles get lodged in joints, causing extreme pain and requiring time spent in a decompression chamber at a hospital. Or it could be an air or pulmonary embolism that can result from ascending too fast, causing those same gas bubbles to expand too quickly in your lungs and heart.

Worried yet? These are the extreme cases, but any diver needs to understand these risks. Like an astronaut in space, so must a diver rely on a totally self-contained life support system to stay alive while working in an alien environment. Recreational diving is generally considered to be scuba diving to depths no greater than 120 feet and applies to about 75 to 80 percent of divers certified. According to international diver certification agencies, recreational divers make an average of eight to twelve dives per year, mostly while on vacation. Wreck divers in New Jersey easily match that and go far beyond, making as many as thirty to sixty dives on average per year and in conditions nowhere as easy as on the reefs of warm Caribbean waters. We weren't built to live or work underwater for extended periods of time. The underwater environment off the New Jersey coast is pretty

A diver on the Shark River Reef, sixteen miles off Manasquan Inlet. *Larry Cohen, www. liquidimagesuw.com.*

extreme with cold water and deeper-than-usual working depths, often with limited visibility underwater and fifty to eighty pounds or more of dive gear on your waist and back. You need to be able to navigate around the wreck and be able to find your way back to the line that takes you back to the boat. All of these conditions get added into your task load or dive plan, and to function well requires exceptional skill, confidence and experience. Many New Jersey wreck divers may also bring bulky underwater cameras or video equipment made larger with waterproof containers to keep them dry and safe. Some bring tools, even utilizing dive scooters, which are normally used to tow divers underwater for navigating the wreck but can be flipped around to blow sand away from a place on the wreck to dig for artifacts. Sometimes bigger tools are needed, and heavy air or water dredges, which are powered by surface-supplied pumps and hoses, can dig a hole on the wreck in minutes. All of this adds to the task load of divers. Your dive plan has to account for the time to set up the equipment, work your underwater mission and, at the same time, build in time to safely ascend from the dive, as well as be able to communicate effectively with other divers.

Technology has helped improve divers' chances and reduce some of the risks of diving. Underwater dive computers have sensors that run mathematic programs or algorithms that constantly track your depth, which allows the computer to "average" your time at various depths and allow you more time underwater. The dive tables assume you always reach the maximum prescribed depth on your dive. The reality is that you may be swimming at various shallower depths until you get to where you are going. Your dive computer then tracks those varying depths and extends your dive time safely since you would not always be at the maximum depth.

The advent of this type of technology, as well as a better understanding of how we breathe gases under pressure, has also extended time spent underwater. The average vacation diver may dive to reefs in shallow water no deeper than thirty to forty feet for short periods of time, usually thirty to forty-five minutes. Wreck divers are diving much deeper and conduct their dives for the same if not longer periods of time, so as more technical methods of diving became available, divers adapted. One of these technical aspects involves the use of Nitrox, which is enriched oxygen (normal air, the kind in our atmosphere that we breathe every day, is composed of 21 percent oxygen, but Nitrox mixes can include anywhere from 22 to 40 percent oxygen). It helps your body by absorbing less nitrogen during the dive and thereby extending your bottom time. Nitrogen can cause an effect known as the "bends," a condition that traps nitrogen bubbles in your bloodstream and in your joints that causes great pain and, in rare cases, death.

The "bends" were discovered when treating coal miners back in the early 1900s who mysteriously developed pain in their limbs after they rose from the depths of the mines. Back then, this illness was called caisson disease or decompression sickness. The fast trips coming up from the mine depths were the cause of those pains. Nitrox is never recommended for dives deeper than 130 feet, as oxygen becomes more toxic medically in the divers' lungs. For dives at depths over 150 feet to well over 250 feet, the use of mixed gases helps in much the same way. As you go deeper, oxygen becomes more dangerous to your body, so mixing in helium with regular air limits the effects by diluting the oxygen content. A gas mix of 17 percent oxygen allows divers to work more effectively in water deeper than 150 feet than those using air (21 percent oxygen). The downside is that diving with less oxygen adds more stress to your body, which has to work a bit harder to make that gas exchange in your lungs and the bloodstream. This is why diving to deeper depths (150 feet or greater) involves having more technical diving education that covers any type of diving that is not considered recreational diving (shallow dives of

Beth Dalzell of Brick, New Jersey, scuba diving one of the many shipwrecks on the New Jersey artificial reef. © *Herb Segars, gotosnapshot.com.*

less than 80 feet) and almost always includes at least one but perhaps two or more decompression stops, which allow your body to off-gas the compressed nitrogen gas that you absorbed while diving.

Let's look at a couple examples. A diver making a dive to the wreck of the *Andrea Doria*, an Italian passenger liner located one hundred miles off the coast in 250 feet of water will use mixed gases to make the dive. That dive for one hour or ninety minutes underwater will require decompression at various depths on the way up, usually starting at 50 feet from the surface. The total run time on this one example dive, including actual time spent on the wreck and all decompression stops before surfacing, might total four to six hours. This is all before you could safely surface. If you did that dive breathing just air with no decompression stops, you would be limited to about five minutes total time underwater.

One other strategy that divers must use is slow ascents. The idea is go up slowly to allow gases that built up under pressure in your tissues to off-gas as the pressure decreases on the way to the surface. The rate of ascent is considered to be one foot per second. So our example dive of 250 feet to the wreck below would require over four minutes just to go from that wreck to the surface. You would have no time to survey or map the wreck. Of course,

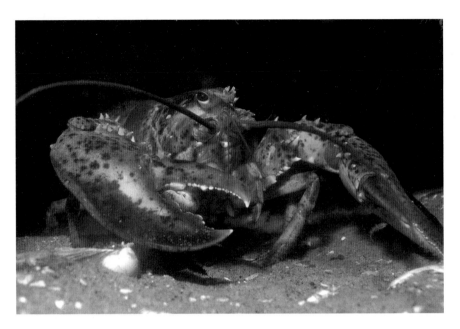

A North American lobster, *Homarus americanus*, the prize often sought by scuba divers. © *Herb Segars, gotosnapshot.com.*

this is overly simplified. No technical diver would calculate in such broad terms. Now, at shallower depths of 80 feet, a Nitrox diver using an oxygen mixture of 36 percent could spend forty-five to sixty minutes at that depth. An air diver using recreational dive planning could spend only thirty minutes maximum, and a U.S. Navy dive table diver would be allowed a maximum of forty minutes. (The U.S. Navy dive tables were based on fit, young male navy divers doing one dive per day with not too much task loading.)

Maximizing your dive time on the bottom allows you to search for artifacts, catch lobsters or do videography or photography of the wreck and marine life. As explorers, you always balance the risk with the benefits of making the dive. It's not all mission-orientated; most times it's just a relaxing dive, enjoying the underwater experience. When your dive requires digging on the wreck to look for artifacts or mapping parts of the wreck to determine information about its construction and possible identification, then dive planning is essential to your safety and your success. Scuba diving in New Jersey can be rewarding, but it is complicated and thus experience is required.

Chapter 2

ANCIENT INDIANS OFF SANDY HOOK

There is a sense of wonder about history when you dive these shipwrecks off the coast and certainly as you research more about them while trying to discern their stories. History is relative to where you are. For example, our country's history only goes back a little over four hundred years. On a diving expedition to Greece a few years ago, however, I had a chance to dive shipwrecks that sank between two thousand and three thousand years ago. That's a lot of history and a long time ago. There is a feeling of both excitement and overwhelming insignificance when you put that experience into context today.

What does this have to do with the next story? I was able to be a small part of an expedition that looked into early—let's call it "prehistoric"—New Jersey history several years ago with Daria E. Merwin, a Stony Brook University doctoral candidate at the time, off the coast of Sandy Hook in 2003.

Dr. Merwin (yes, she received her PhD) was trying to prove her thesis, "The Potential for Submerged Prehistoric Archeological Sites Off Sandy Hook," published in the 2003 *Bulletin of the Archeological Society of New Jersey,* that ancient Indians had lived along the New York Bight ten thousand years ago and left traces of that existence in what is now the beaches off Sandy Hook. A surprising opportunity came from an unlikely source during an Army Corps of Engineers beach nourishment or replenishment project. As a result of all the beach replenishment, a West Long Branch woman who was out beachcombing looking for sea glass on Monmouth Beach a few miles south of Sandy Hook wound up discovering over two hundred

arrowheads and other artifacts. A few of the artifacts were later scientifically dated to be from the Early Archaic Period. Archaeologists divide the Archaic Period into three sub-periods: Early, Middle and Late. Each subsequent period is distinguished by important changes in cultural conditions and social complexity. It turns out those arrowheads were between eight thousand and ten thousand years old, from the beginning of this period. It's no surprise that Indians lived in the area, but it was surprising to find out that those arrowheads came from the general area from which those Army Corps engineers were pumping sand.

The process of beach replenishment involves pumping sand from an offshore site through large hoses onto the shore beach. The sites can be a few hundred feet or miles and are chosen by the bottom material and, of course, the logistics in accessing it. Natural erosion takes place from storms and ocean currents. In Sandy Hook's case, this current is called the littoral or longshore drift current, which moves sand and water northward. Predominate wave and swell directions are from the southeast and contribute to the erosion. As storms and currents take sand away, the coast becomes more susceptible to storm damage and tidal erosion, so replenishing the sand back onto beaches and building those beaches as a barrier to that erosion is an important task to protect shore communities. This process has been ongoing for many years. It has its share of supporters and critics for its cost and for its protection of shore communities.

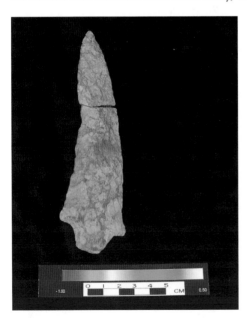

A beautiful example of a transitional period argillite spear point recovered from Eel Skin Rockshelter. This type of rock was heavily traded from the area. *State Museum of Pennsylvania at Harrisburg.*

Hurricane Sandy and the many nor'easters in the area remind us every year of the need to protect our homes from the onslaught of the ocean. The narrower or shorter the beach, the more likely waves and tidal erosion will encroach on the land and potentially flood and destroy homes and property. So we endeavor to refill the beaches to

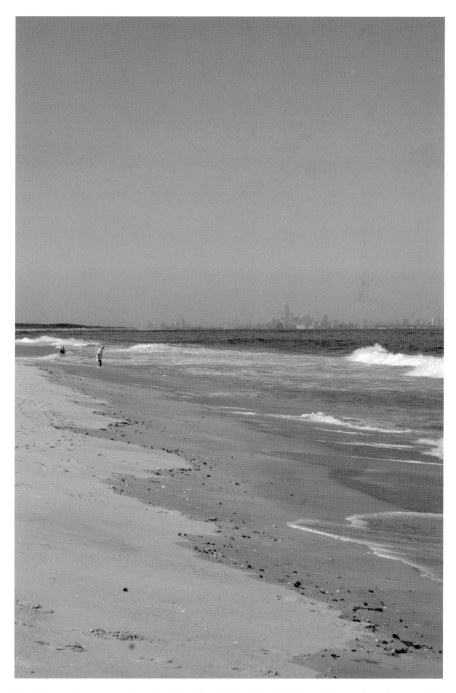

Ten thousand years ago, the view from Sandy Hook looked a lot different than this one with the New York City skyline in the background. *Author's collection.*

buffer us from the ravages of the ocean. The coast is constantly changing, if only on the small scale of currents and storms. What happened ten thousand years ago was the result of long-term geological changes.

Perhaps a little geologic history is in order to understand both how and why those arrowheads and artifacts might have wound up there. During the last 40 million years, the world has undergone several different glaciations periods when continental ice covered most of Canada and the northern portions of the United States. North Jersey was influenced by varied glaciations during the past 3 to 4 million years. When the ice melted and glaciers retreated, water returned to the oceans and sea levels rose. When the ice re-formed and expanded, it caused shorelines to expand. This was the case approximately 7,000 to 15,000 years ago when the last ice sheet covered much of the northern parts of the planet. Sea levels were at the lowest during this time period, almost 330 feet (100 meters) lower than today.

The current seafloor or continental shelf off our beaches is reasonably shallow—250 feet offshore to 50 miles—so ten thousand years ago, that continental shelf was likely mostly dry or marshy land, easily traversed by the nomadic Indians of the era. That era is referred to as the Early Archaic Period.

Archaeologists say the Delaware Indians were the original residents during that time. They were hunters and gatherers, and they seldom stayed in one place, often moving from place to place to hunt, fish or gather plants for food. They were living during a warm-up period in climate, and vegetation and pine and spruce trees began to again appear.

Archaeological sites indicate they used oyster as food and the shells for tools. Mounds of these shells were good indicators that an Indian settlement might have existed there. These oyster shells were large at eight to ten inches long, something not typically found today. Those mounds of shells, called "middens," are located along the coastlines around the state from Sandy Hook to Cape May, with the largest being located off Tuckerton, in Ocean County. These middens are present all along coastlines in North and South America. They are indications of the earliest inhabitants. These middens are hard to find as farmers crushed the shells and used them for their lime content in farming or crushed them and used them in building old roadbeds. So now it easier to understand how Indian artifacts might have shown up along Jersey beaches.

Getting back to ancient Indians and Sandy Hook, Merwin stated that such artifacts would help prove her thesis that prehistoric Indians lived six thousand to ten thousand years ago on the exposed continental shelf before it was inundated by water from melting glaciers. She was given permission

to conduct basic underwater surveys off Sandy Hook, which is, of course, a National Recreation Area, managed by the National Parks Service. Professional archaeologists stated that finding evidence would be a long shot, but it was also a groundbreaking expedition, looking in places that few ever had before. In a *New York Times* article in July 2003, article author Robert Hanley quoted Dr. Lorraine Williams, the former New Jersey state archaeologist, who said, "People for years have tried to figure out how to explore the ocean bottom. Nobody's really come up with clear evidence of prehistoric sites offshore." Looking at examples of arrowheads there seems to be a great case for it, even if it'll be difficult to find the old campsites now that they are underwater at least a few miles offshore. The arrowheads or spearheads that were found on the beach were fashioned from various rocks and minerals like basalt, jasper and other unidentified sedimentary rocks, perhaps shale or slate.

This story gets even more interesting because over the past few years more arrowheads have been found along the Jersey Shore. Most recently, a Lanoka Harbor woman who was also beachcombing for sea glass off Seaside picked up an ancient arrowhead, and after it was brought to the State Museum of New Jersey in Trenton, experts there confirmed its authenticity at an age of ten thousand years. Still think it a coincidence? In 2014, according to a *USA Today* story, a ten-year-old boy from Virginia on vacation on Long Beach Island found another arrowhead off Beach Haven. Experts from the State Museum of New Jersey also confirmed this find as authentic. The experts list twenty similar finds in their own collection from professional archaeological dig sites. It has to be a great feeling not only to find such an artifact on a beachcombing walk but to actually hold in your hand evidence of ancient people in our state, especially knowing that those artifacts came from some ancient offshore campsite or settlement.

It seems like beachcombing is producing pretty good results so far. Perhaps another beach replenishment project will uncover more. This is probably a good bet, as opposed to waiting for glaciers to lower sea levels again, but it seems that global warming may actually increase our sea levels. Many climatologists and geologists say the sea has been rising for the last one thousand years at a rate of four millimeters per year, which, in another one thousand years, would be result in a thirteen-foot sea level rise in 3015. If that sea-level rise keeps going up, I often wonder what artifacts from our life in New Jersey future archaeologists would uncover in 7015 or 8015 and what conclusions they might make about us.

BURIED BEACH WRECKS

JOHN MINTURN, AYRSHIRE *AND* NEW ERA

I am not afraid of storms for I am learning how to sail my ship.
—*Louisa May Alcott*

B uried beach wrecks tell the tales of ships and people who were caught in the gales that appeared with ferocity seemingly from nowhere. The shorelines could often be dangerous for ships that sailed too close, but those same shores could provide salvation for the passengers forced to abandon their sinking ships and seek salvation on the very land that caused their wrecking. The stories chronicled here include key moments that helped to change maritime history and tragedies that taught us how better to rescue ships and protect the people who sailed in them. These shipwrecks started the Life-Saving Service, and some of those stations still stand today as museums and memories of the heroes who saved lives while risking their own. This service and its stations would eventually become the United States Coast Guard.

There are various types of sailing ships mentioned in these pages, and it's easy to be confused about which is which. Sailing ships are basically described by the number of masts or their rigging and sails. Many have the same number of masts, but their sails are different or the heights of the masts change. Some basic definitions of the rigging of sailing vessels: the rigid cross members that carry the sail of a vessel are called spars, and the vertical spars are called masts. An angled spar extending from the bow is called a bowsprit, usually found at the ship's bow. Horizontal spars that cross the masts are called yards, and a horizontal or angled spar, which is anchored at one end to a mast and

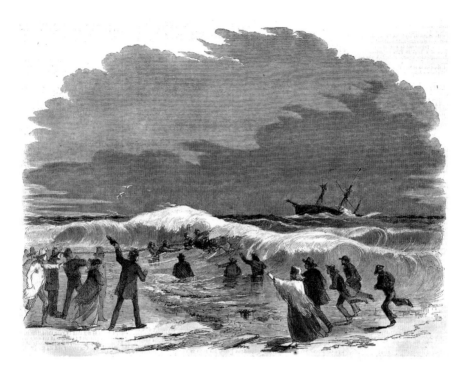

An illustration of the wrecking of the *Adonis*. *Author's collection.*

supports the top of a sail, is called a gaff. Finally, a horizontal or angled spar that is anchored at one end to a mast and supports the foot of a sail is called a boom.

Common names you probably have heard or read about include a bark or barkentine, which is a sailing vessel with three or more masts—fore and aft rigged on the aftermast, square rigged on all others. The barkentine is a vessel of at least three masts similar to a bark with fore-and-aft rigging of the mainmast. The foremast is made in three spars in square rigging, but the main- and mizzenmast carry hoist-and-lower mainsails and gaff topsails of the schooner type. A brig is a two-masted sailing vessel with both masts square rigged. On the stern-most mast, the main mast, there is also a gaff sail. A brigantine is a two-masted sailing vessel in which the foremast is square rigged. The mainmast carries a fore and-aft mainsail, above which are a square main topsail and topgallant sail. A clipper ship is the classic sailing vessel with a long, gracefully curved bow and swept hull. Clippers are sometimes referred to as the greyhounds of the sea. These types of ships were usually merchant ships, designed for speedy passages.

While a packet ship most often refers to a sailing ship that sails between two or more ports on a regular basis, it doesn't necessarily have to be a sailing ship. Schooners are not a specific kind of vessel but describe many ship types. What every schooner has in common is that it is mainly fore-and-aft rigged (the main sail must be a fore-and-aft sail) and that it has at least two masts (a foremast and a mainmast; a two-masted vessel with a mainmast and a mizzenmast is not a schooner). A fore-and-aft sail is a sail that can take the wind from either side of the sail, depending on the direction of the wind, as opposed to the square sail that is always turned so that it takes the wind on the same side of the sail. Dictionary.com lists the nautical definition, but it also recognizes in its definition another type of "schooner": a very large glass of beer—and after trying to figure out which type of sail-rigged ship is which, a large beer isn't a bad idea at all.

During the eighteenth and nineteenth centuries, ships traveled along our coastline because it was easier to navigate than in the open waters. These were mostly sailing ships but not all. Captains sailed within sight of land whenever they could. It was comfortable and made navigation easy for as long as land lasted. Land provided passengers and crew a familiar reference, helped them to feel safe and to hail passing ships for information or for provisions and needs or rescue if the untold happened.

That didn't mean storms, accidents and dangers didn't exist or happen regularly—in fact, they did. For as long as men sailed the seas, they mapped their courses, charted harbors and noted landmarks. It wouldn't do to get caught offshore in a gale, but as the ships came in closer to the beaches, there were other hazards that could harm the ships. These are called sandbars, and theses bars led to many shipwrecks when ships became stuck on them as they were pushed toward shore by the gales. Once on the bar, the fury of the storm and wind-whipped waves would pound the ship to destruction. In the nineteenth century, the Jersey shore was a dangerous place and caught many ships unaware of the dangers until it was too late. Ferocious storms would sneak up so quickly that ships didn't have the time to find a safe route or harbor. When the storm was upon them, if they couldn't outrun it or sail through it, the master would order the ship to approach the shore, where passengers and crew had a chance to survive.

New Jersey doesn't often experience hurricanes. The state is located too far in the northern latitudes and in colder ocean waters that help extinguish the energy of a hurricane rather than the warm waters in the south that fuel the storms. We do get nor'easters though, all the time. In fact, the latest occurred in October 2015 when we experienced a serious nor'easter that

caused extensive beach damage and tidal flooding. This elicited a request by Governor Christie for federal disaster relief funding to repair those beaches hit by severe erosion from wind, waves and tidal action. In late October 2012, Hurricane Sandy or, as it was later called by East Coast residents, Superstorm Sandy did extensive damage to our coastline.

Most of these storms are weak and give us just a lot of rainfall, but the exceptions are more powerful than some hurricanes. Nor'easters can generate high-speed winds and tidal flooding and are more feared because they last for one or two days in many cases. A hurricane may reach category 5, but once it hits land it expends its energy quicker and subsides somewhat. This isn't to dismiss hurricanes. Superstorm Sandy was devastating, and as it crossed onto land in Brigantine in 2012, it dropped from a category 1 hurricane to tropical storm strength. But that storm was so extensive, carrying so much rain and wind that its impact was catastrophic. It devastated most of coastal New Jersey and caused major power outages all over the state. Much of our shorelines lost beach sand and homes and experienced damaging flood and tidal waters from nor'easters.

The modern aids to navigation like GPS, Loran or radar and sonar and the instant communications that we enjoy today make it possible to go anywhere in the world and be able to see weather approach. Using this technology, we can know the water depths along almost every coast and talk to other ships or the coast guard, if necessary, or even communicate with vessels' corporate offices. Two hundred years ago, sailors had no such technology. They traveled by following the coasts whenever possible. Sure, they could navigate by using the sun and stars coastwise or across the oceans. They had to find ways to save themselves. There were no radios or cellphones to call for help, and for a long time, there was no coast guard to call on in emergencies.

The Wreck of John Minturn Leads to the Founding of the United States Life-Saving Service

The wreck of the *John Minturn* off Mantoloking is among the most significant events in local New Jersey maritime history. The shipwreck and several others during that same storm in the early morning hours of February 15, 1846, so shocked the nation that the United States Life-Saving Service

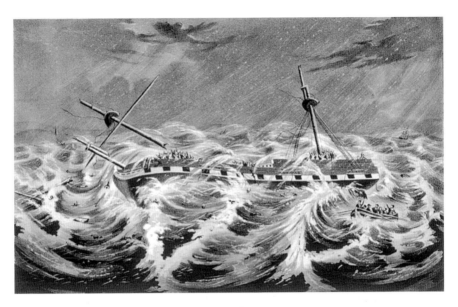

The Wrecking of the John Minturn. Illustration by Nathaniel Currier. *Dan Lieb and the NJHDA.*

would eventually be created. But let's begin with the story of the *Minturn*, the people aboard her and the folks who tried their best to save them.

The day began innocently enough on Valentine's Day, though it would turn out to be anything but a happy holiday. Approaching New York, the packet ship *John Minturn*, a beautiful three-masted ship under the command of her master, Captain Stark, was about to pick up the harbor pilot. The harbor pilot has specific local condition knowledge of the harbor and is taken on board a ship to help advise and guide the captain into harbor safely. This process can trace its history back to early Greece and Rome. In the case of the *Minturn*, after coming aboard, the pilot cautioned the captain to "reef the topsails." This means simply reducing the amount of sails rigged. The pilot knew that a weather front was moving in, and reducing sail area seemed prudent. Captain Stark thought it over but considered it unnecessary. By evening, the temperature turned freezing, and the rain turned to snow and intensified. The wind was already howling out of the northeast and fast approaching gale force strength of over fifty knots.

The entrance to New York harbor has a narrow opening, and the approaching nor'easter would make traversing it dangerous. At midnight, the wind was howling with terrifying force, and with it, a nor'easter had developed. With her sails reefed, the fierce winds had pushed the *Minturn*

farther south and closer to the shoreline. Before dawn, the screeching winds ripped away the remaining sails. Had the ship's sails remained intact, her crew might have kept the ship off the beach.

At daybreak, the winds grew stronger, and with the aft sails ripped away, the *Minturn* was now left to the mercy of the seas and winds with no way to control her headway. The plan would be to head for the beach to give the passengers and crew the best chance for salvation, but if the ship turned broadside into the horrific winds and seas, she would roll over and crush everyone aboard.

All during this drama, the ship moved closer to the beach. She skid over a shallow sandbar a few hundred yards from the beach but hit hard on another, and the ship's hull broke under the strain. Her masts gone now, the ship was doomed. It would only be a matter of time before she broke apart. Her crew worked furiously to launch a small "jolly boat" (Historical note: we would call this a dingy, a smallish boat used to ferry a very small number of passengers back and forth from ship to shore. The tragedy of the *Titanic* was that she did not carry sufficient lifeboats for all passengers and crew onboard, and so many perished that might not have had there been enough boats for all to escape.) In much of the nineteenth century, lifeboats were not usually carried aboard ship, but rather they used these jolly boats. Lifeboats were an expensive option, so seldom were there enough of them aboard merchant ships. Even if they were carried, sail or oars powered them, which was difficult at best under normal conditions. Imagine trying to launch one from a destroyed ship with ten- to fifteen-foot waves breaking over her hull as she lay across the beach, quickly being smashed to pieces by the relentless waves.

All during this time, the scope of the Great Storm of 1846, or what was often referred as the "*Minturn* Storm," was being felt all along the central New Jersey coast. In a wreck off Sandy Hook, the pilot boat *Mary Ellen* was chased inshore, and her captain intentionally drove her onto the beach, where all her crew survived. Also wrecking on Sandy Hook was the schooner *Pioneer*, driven broadsides onto the beach with her cargo of cornmeal, her crew rescued by a local resident who managed to use lines from the masts to bring ashore the captain and crew. The *Antares* was a coastal collier that had picked up a cargo of coal bound for Boston. The icy storm pushed her ashore off Monmouth Beach. A local resident spotted the ship and upon coming down to the beach, spotted her crew in the masts, from which he grabbed lines and towed them safely ashore in the freezing surf. The sailing ship *Register* beached at Long Branch with her cargo of turpentine. Two local

men pulled the crew ashore, with one passenger losing his life. The schooner *Van Zandt* was lost near a beach somewhere between these last two wrecks. No information is available about her.

It was a very busy time for wreck-masters. The expanse of beach they covered was great, and now here were ships wrecking all along their areas of responsibility. They were overwhelmed. Sunk off Deal Beach was the schooner *Arkansas*. She was also bound for Boston with a cargo of corn. Her crew hung on to her rigging as she hit the beach and broached in the rough surf. Two local men rescued most of her crewmembers, but unfortunately, the ship's boy drowned. (Historical note: young boys were often carried aboard sailing ships to run errands for the captain and his officers. One notable cabin boy was Thomas Nickerson, who would co-write the survival tale about the whaling ship *Essex* in the Pacific in 1820—a story that would eventually become the novel *Moby Dick* by Herman Melville.)

The *Minturn* Storm wasn't done taking out her raging fury on ships along the New Jersey coast. The next victims would be the barks *New Jersey* and *Lotty*. They wrecked within three hundred feet of each other in between Manasquan and Shark River Inlets, about eight miles from Point Pleasant. The captain and crew from *New Jersey* landed quickly and safely, but not so easy was the rescue of the crew of *Lotty*, which struck a sandbar broached. Waves crashed into her, pushing rescue boats a mile up the beach. To get an idea of the situation and conditions in which these men and ships found themselves, here is a comment from the *New Jersey*'s Captain Lewis, who stated, "The surf was raging to such height that it appeared impossible to take men off, but there were some true-hearted and daring men who risked their own lives to save those aboard *Lotty*."

The final casualty of the storm besides the *John Minturn* would be the schooner *Alabama*, also sailing up the New Jersey coast to Boston. She carried animal hides, iron and spices. Surf man Thomas Cook, who would help on the *Minturn*'s rescue, was among the first on the scene. He noted, "What time she struck in that dreadful storm no soul has lived to tell. No doubt long through the night and morning their wild shrieks for help mingled with the tempest, but they were not on time and every soul aboard the *Alabama* perished."

In all, ten ships would flounder and break up into pieces along a thirty-mile stretch of the New Jersey shore on this day along with the *John Minturn*. Many passengers and crew were saved by herculean efforts of surf men and locals, but many others perished. The tenth and final wreck would be the *John Minturn*, wrecking off Mantoloking. The bodies of her captain and many

others would wash up along an eight-mile stretch of beach, punctuating the storm's devastation and battles against the sea.

Wreck masters from the surrounding coastal areas were busy during this storm, trying to get resources to do what they could for the survivors, but there were no mechanisms in place for organized rescue. Usually the first men on the scene tried as mightily as they could to help the passengers and crews of the wrecked ships until other rescuers could arrive to help. These men tried to launch boats and throw lines toward the wrecked ship in the hopes they could be grabbed by the ship's crew (or perhaps one of the passengers aboard) who could tie the lines off on a sturdy structure aboard the ship, thus providing a method of rescue. Many times the winds and waves would beat back these efforts, and the wreck masters could only watch and listen in horror to the shrieks and screams of desperate men and women clinging to shrouds of tattered sail or broken spars and rails waiting to be saved, all the while knowing that these poor souls would have slim chances of survival. They witnessed passengers, one after another, drop into the icy and turbulent waters. Many drowned or succumbed to the numbing icy-cold water.

The wreck masters weren't always alone. Word of the disasters quickly got around through the communities. Some of the local residents offered to help, but many just watched the drama unfold. This was normal at the time. People were fascinated by these events, and I'm sure each of them would sympathize with the victims but were leery of putting themselves in the danger of splintering ship, crashing waves and brutal winds and cold. Even with volunteers and professional rescuers, the widespread and powerful storm drained the available resources from many of the shore communities, adding to the losses of passengers, cargo and ship. Yet there were many survivors from shipwrecks created by the Minturn Storm. The greatest tragedy would be among the passengers of the *John Minturn*.

The *Minturn* was not to be saved, and the aftermath of her sinking would be felt for many weeks. Local surf man, (the surf man certification was the highest honor attained in the newly formed Life Saving Service) Mr. Cook was on the beach as bodies washed in. Most were frozen in grotesque positions. One survivor from the crew noted that the body of the harbor pilot was frozen and covered in ice but still gripping the ship's wheel. Despite eighteen hours of rescue efforts, over thirty lives were lost, including those of the captain, his wife and their two children. The captain's body would wash ashore in a mangled heap of broken limbs—cruel testimony to the viciousness of the storm and wrecking.

Accounts of the time speak about the mass of wreckage being tossed amid the waves, further endangering victims and rescuers. Men were waist deep in the rough surf trying to get lines and boats to the *Minturn* only to be turned back by waves breaking over their heads. In total, ten were saved. The dead were identified mostly by what they wore or carried on them. On shore, Monmouth County coroner George White had the job of dealing with identification, inventorying possessions and burying the dead. Traveling from Point Beach to Mantoloking—over twelve miles—he counted the bodies and carefully numbered and described them, leaving rings on fingers and other identifying personal items. He even posted as many as four guards to facilitate handling and identification. He placed the bodies in the Methodist church in coffins to be claimed by family members or friends. Almost two weeks after the wrecking of the *Minturn* on February 25, all but eleven of the bodies had been claimed, and it became necessary to bury these eleven as quickly as possible.

After the storm ended, the remains of the wreck *John Minturn* were attracting the attention of the local populace around Mantoloking and the surrounding towns. Many of the onlooking citizens criticized the wreck masters as cruel opportunists, ignoring the drowning passengers while looking to salvage anything of value from the wreck ship when in fact very little of this actually went on.

There have long been rumors and tales of piracy or perhaps opportunistic residents who would lure coastal ships ashore during storms. These tales are woven into the local history of many coastal towns and settlements all over the world, not just New Jersey. The stories were not so easily dismissed because so many of the coastal residents' homes included recovered pieces of wrecked and abandoned ships that had washed ashore. While pirates have always existed, I suspect the residents at the times would find these wrecked ships off their beaches during storms and did what they could to rescue any survivors and clean up the remains of the wreckage, perhaps keeping things of value they could use that had not been claimed by the company or insurance agent.

In fact, an inquiry was held on the orders of then New Jersey governor Charles C. Stratton, who appointed men to investigate charges of wrecking and pillaging the wreck and passengers of the *Minturn*. The value of the ship's cargo of cotton, hides (leather) and food was valued at between $75,000 and $85,000. That was a fair bit of money back then, and using consumer price index calculators, it can be determined that this cargo would be valued at over $8 million today. This would surely be a potential bounty

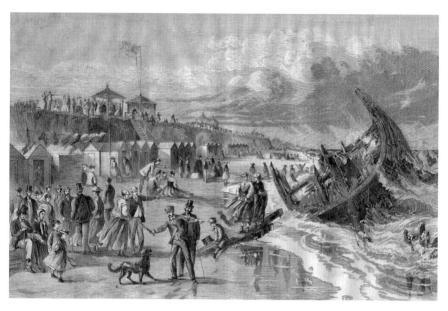

Harper's Weekly image of the onlookers at a shipwreck on the beach. *From* Harper's Weekly.

of goods for locals who made do with much less every day. Charges that local lifesavers had looted bodies and the $80,000 cargo were found to be untrue by a special commission created by the governor of New Jersey. In fact, the commission went above its charge and praised the courage of the locals. This commission interviewed over forty witnesses, including many survivors and their rescuers, as well as some local residents and the wreck masters. Each voiced the same belief that all of the men did all they could to save the passengers of the *Minturn*. Mr. Cook, surf man and one of the rescuers, was from one of the original families in the Point Pleasant area. His farm and home were likely one of the first bed-and-breakfast places for area tourists, and no doubt the story of the *Minturn* came up at the evening dinners over the years. Tommy Cook would always discuss his role in the *Minturn* saga to anyone who visited his shore home. The following quote has been attributed to him:

> *The most fearful storm I ever witnessed was that February 14, 1846. I was awakened at four o'clock in the morning, by the shaking of my bed, as the wind threatened to blow the house from its foundations. While the storm was at its height, about nine o'clock in the morning, we saw just off the shore, through the spray and sleet, the* John Minturn, *an*

American barque, with all her sails swept away, drifting to the southward, and approaching shore. She struck to the south of us, about an hour later, where hundreds had gathered, knowing that nothing could save the vessel.

Those on board were not idle. After several attempts and failures, two sailors entered a boat with a rope, and put off for shore. The current carried them so swiftly to the southward, that they were compelled to cut the rope, to save themselves from capsizing. They came safely ashore with the last boat, and found it impossible to return.

At eleven o'clock at night with the storm still raging the Minturn *went to pieces. We could hear the wailing shrieks that went up from the despairing ones, as the sea at last caught them in its merciless embrace. The cold was intense, and when the bodies came to in the shore, many were found frozen as rigidly as statues. Quite a number, I recollect, stuck in the beach in a sitting position, and thus we saw dead men sitting as upright as in life, as we drew them out of the way of the waves.*

The wrecking of the *Minturn* and all of the vessels lost during that "*Minturn* Storm" represented a great loss of life, and the circumstances of trying to rescue so many with not enough resources was a focal point in developing what would become the Lifesaving Service. Local wreck masters had long requested competent surfboats capable of managing the rough surf and conditions found during these storms that brought wrecks to shore.

It would be into the following year of 1847 that newly elected second district representative Dr. William Newell, whose responsibility would extend the Jersey Shore from Sandy Hook to Little Egg Harbor Inlet, would push for lifesaving stations along the coast and closer to one another so that rescuers from many stations would be better able to react quickly to future disasters and share resources, eliminating the need to travel great distances to reach a remote spot of a future shipwreck. Dr. Newell, who knew firsthand about how these disasters could play out, was himself a witness to shipwrecks on Long Beach Island and had participated in a rescue of a wreck on the uninhabited shores of Long Beach. But the bay men he was with could do nothing to help the men aboard the brig that wrecked on that beach. They didn't have enough warning to react in proper time and had to travel too far across vast expanses of sand and brush to reach the stricken men in time, not to mention the arduous trip across the bay to get to the barrier island. That experience resonated so much with Dr. Newell that he would be the one who spoke out for funding and developing rescue stations along the coast. It was a battle to secure funds, and it wasn't until 1848 that Congress

approved a bill to provide money. Newell's district was largely uninhabited along the beaches, with the exception of the small village of Squan Beach. Early residents of coastal New Jersey were largely farmers and located on the mainland. Unless a ship could be seen, no help could be quickly brought to the site of a ship in danger. Survivors might make it ashore only to be unable to seek shelter or medical help.

Initially, the government allocated money for eight lifesaving stations. The first was built at Spermaceti Cove on Sandy Hook. In fact, you can visit this station, now a historical museum, and see how it was set up and operated. The remaining seven were built and in place along the shore to Long Beach in what is now Beach Haven by mid-1849. They were generally no larger than small bungalows and designed to be moved if necessary from severe tidal flooding. It was from these stations that techniques and devices—like the Francis Lifeboat, mortar-powered lines and efficient, sturdy, lightweight wood, surf-capable boats (similar to what you see on beaches in New Jersey today at most lifeguard stands)—were developed to save lives. The Francis Lifeboat figures prominently in our next story. Toms River boat builder John Francis built this iron boat. It featured such innovations as air chambers and was coated with rubber and fenders. It was untried. That would change very early in the new year of 1850.

WRECK OF THE *AYRSHIRE* AND NEW LIFESAVING TECHNOLOGY

Many of the ships heading to the United States during this period were bringing in from all over Europe immigrants hoping to improve their lives in this new and opportunity-rich country. Most were poor, using whatever resources they had left to buy passage on the ships headed to the United States. These were the folks on the *Ayrshire*: Irish immigrants leaving the famine of Ireland behind. During the period from 1845 through 1854, the Great Famine was happening in Ireland.

The potato was the singular crop for many of the farmers in Ireland, especially the poor, for whom it was almost the only food source. It was easy to grow; required a cool, moist climate; and had a generous yield of crops for the space these tenant farmers were able to spare. That reliance on it was about to catapult the entire country into chaos. The potato blight began in 1845 when almost all of the potato crop was infected with the airborne fungus *Phytophthora infestans*, which likely came to Ireland in the holds of ships

from other countries. The blight rotted potatoes in the ground and rendered entire fields inedible. Worse still, the fungal spores were blown with the cool winds and settled on the leaves of healthy potato plants and multiplied to surrounding plants as well. With the right conditions, a single infected potato plant could infect thousands more in just a few days. The attacked plants fermented and rotted while providing the nourishment the fungus needed to live, with the crops emitting a gaseous, nauseating stench as they blackened and withered in front of the disbelieving eyes of Irish farmers. This blight was something never seen before. Crops had been destroyed by weather or disease but not as completely or quickly.

William Trench, land agent for County Cork at the time, wrote, "The leaves of the potatoes on many fields I passed were quite withered, and a strange stench, such as I had never smelt before, but which became a well-known feature in 'the blight' for years after, filled the atmosphere adjoining each field of potatoes. The crop of all crops, on which they depended for food, had suddenly melted away."

Ireland was still a very fertile land and grew many crops, but these were "cash crops" owned by large landlords and to be used for export to make money, not for feeding the poor who surrounded them. This itself became more the battle in later years as the government tried to open up these crops to tenant farmers. The tenant farmers lost everything with the loss of their potatoes. While some landlords allowed their tenants to retain grain crops for food and reduced their tenants' rents or even waived them, others were less obliging. This bailiff's remark as quoted in the *Freeman's Journal* in April 1846 was typical of many of those landlords who took their tenants to the courts: "What the devil do we care about you or your black potatoes? It was not us that made them black. You will get two days to pay the rent, and if you don't you know the consequences." There was now nothing for the poor to eat. Although many had enough land to grow crops other than potatoes, they were caught in an impossible bind: they had to sell these crops to pay rent or face eviction.

Many of the landlords could have done little even if they had wished to, as they, too, lost everything. Their tenants could neither pay the rent nor work their fields because of this blight, thus the value of their land plummeted and their income was gone almost overnight. Many were forced to sell their land for what little money they could get and leave the country. Many hundreds of thousands of Irish died of starvation or disease, and more than two million others emigrated during this period. Whole families and even whole villages left, no longer able to keep up their lives even as sparsely as

they had lived. Those who could afford to leave were considered to be the lucky ones, though they may not have felt particularly fortunate. Many of them traveled on dangerous and overcrowded ships, on which considerable numbers died. Hundreds of thousands sailed for the United States, Canada, Britain and Australia, which brings us to the over two hundred Irish and English immigrants aboard the Scottish bark *Ayrshire* or *Ayreshire* (it has been spelled both ways in publications).

It was New Years Day in 1850 that saw the Scottish bark *Ayrshire* plowing her way through tumultuous seas driven by gale-force winds in this nor'easter off the New Jersey coast. It was all her master could do to keep her steady on a course up the coast. Blinding snow limited visibility, and rough seas tossed the ship about until she contacted a sandbar somewhere off the Absecon Island beach. The gale was in such force that her sails were blown away and her masts snapped, and her rudder damaged. Fate was not yet through with the *Ayrshire*, however. The storm continually assaulted the vessel until she was forced off the Absecon Island sandbar and moved farther north uncontrollably by gale-force winds and seas.

The force of the nor'easter was dying off, but the ship—now without sails or rudder—didn't have the means to steer and move. The *Ayrshire* drifted for a few weeks a victim of the coastal currents and winds, and she

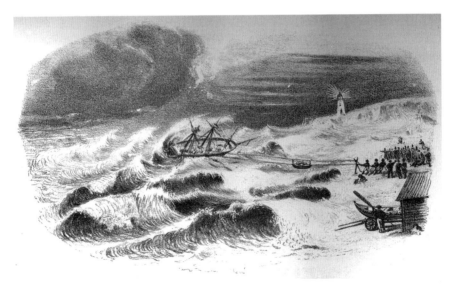

This drawing of the wrecking of the *Ayrshire* off Squan Beach shows the Francis Life-Car being used to rescue over two hundred of the ship's passengers. This was the first time this device was used. *NOAA.*

sometimes drifted in clear sight of the deserted beaches along the Jersey shore at this time but with no means to reach the safety of land. Her bad luck continued as another nor'easter blew up. This storm succeeded where the first had not and beached the *Ayrshire* on Squan Beach (now called Manasquan Beach), almost fifty miles from where she had first hit a sandbar off Absecon Island, and was damaged beyond repair on January 12, 1850, after she had endured two powerful nor'easters in a little over two weeks. The snow was coming down so hard that passengers and crew members could hear the ship hit the sandbars and breech and break her wooden hull, but they couldn't see land even though they were a few hundred feet from the beach. The force of the wind turned the ship on her side, and it was cold, made even more so by the blustery winds. The poor immigrant passengers did not have the clothes to protect them.

One story from a surviving passenger stated:

> *About fifty women and children were in the mates house on deck, a room hardly 20 feet square and water got in there after a while so that the children were in water up to their knees. It was about one o'clock when we saw a flash from the shore, followed by a report and a line fell across the ship. The ship lay over so far that one side was almost underwater and the men were compelled to come by and pass strips of blanket and rope around the women for fear they would slip overboard. The wave beat against the weather side of the ship with fearful force, keeping a continual shower of water flying over everybody on deck.*

Chadwick's Lifesaving Station had recently received one of John Francis's life-cars, and Station Keeper John Maxson, a prominent wreck master, really wanted to give the life-car a try. The seas were too rough to launch surfboats, and it looked like the perfect opportunity to launch the new device. The Francis Life-Car was developed by inventor Joseph Francis and manufactured by the Novelty Iron Works in Brooklyn. When finished, it was installed at the new Squan Beach, New Jersey lifesaving station in 1849. Boat-shaped and buoyant (it was covered in cork), the iron life-car was hauled between a stranded vessel and the beach on stout ropes. The Francis Life-Car was used to transfer the passengers and crew safely from a floundering vessel. It was an innovative device because it fully encapsulated up to four victims in a watertight metal pod-shaped container covered in cork, which helped make it floatable. Wreck masters would fire a line by way of an explosive cannon-like gun from the beach to the ship. The crew aboard ship made fast

the line and would transfer the passengers by this Life-Car to the beach with lessened danger of harming them during the rescue.

He spotted the ship near midnight and set off a flare to let the passengers and crew know help was at hand. After his second shot launching a line to the ship, he succeeded in hitting the mates house, right where the women and children where housed. The recue would begin, but the life-car had some limitations—only four passengers could fit at a time, and it was a difficult process fitting people inside. The rescue took two days and many trips back and forth using the Francis Life-Car, which had proved itself to be an invaluable lifesaving device on its first try.

Imagine, if you can, the ride through the breakers to the beach confined in a metal and cork–covered container as the wind and waves banged it about. It was, no doubt, a terrifying experience, despite knowing they would be saved, and several passengers called it a "bone-jarring ride." Several of these rescues would happen every hour. The first day, more than three-quarters of the passengers and crew members had been safely removed. Among them were Irish immigrants fifty-year-old John Woods; some of his siblings; his thirty-year-old wife, Lydia; and their three sons, a two-year-old and infant twins. The family came ashore in the Francis Life-Car. By late evening on January 12, after the wrecking, the storm and seas had subsided, and it was considered safe to leave the remaining passengers aboard ship until early the next morning, when the final passengers could be safely taken from the wreck. The only casualty of the shipwrecking was one young man who wouldn't wait for his turn and jumped onto the life-car while carrying his children. The waves knocked him off, and he drowned in the surf. Some of the survivors of the wreck settled in New York, while John, Lydia and their children continued on to Canada, where they established a farm north of Toronto.

There was much discussion about the lifesaving services all during this time, as ships were wrecked, passengers died and cargoes were lost. The concern was that there was no clear organization or methods to help save lives and ships. The wreck of the *Ayrshire* provided the first valuable tool for wreck masters in the use of the Francis Life-Car. It had just helped save all but one passenger. Men on both sides of the Atlantic took note. Shipwrecks and life saving was a concern around the civilized world. The shipwrecks along the New Jersey coast—*John Minturn*, *Ayrshire* and later the *New Era*—would play a pivotal role as the catalysts for change, and the United States Life-Saving Service would be born several years later in 1870 due in large part to the

tragedies and lessons learned with these shipwrecks. People wanted to be safe, and too many ships were being lost—perhaps unnecessarily so. The *Monthly Nautical Magazine*, a publication for ships' masters, quoted readers' beliefs, saying, "The public mind is fast becoming awakened, and will not fail to adopt some measure for securing the better protection of human life. A far greater degree of responsibility must be imposed somewhere."

The value of the lifesaving service and specifically the Francis Life-Car was being discussed in all manner of publications. One in particular is called the *Proceedings of the Literary and Philosophical Society of Liverpool*, which was founded in 1812 and became one of the oldest learned societies in England. It exchanged publications with other societies and contained many scientific works presented by the society's authors. There was one article presented in *Proceedings* that had some relevance to the story of the wrecking of the *Ayrshire*. A British civil engineer and member of this organization, Mr. Charles Beloe, proposed a paper evaluating the United States Life-Saving Service, and it included this incident of the rescue by life-car of the shipwreck *Ayrshire* as an example. It appeared as a reference in the Seventy-First Session in 1881–82, thirty-one years after the wreck of the *Ayrshire*. From the selected comment below, it is interesting to see how well these men understood the situations, and this quote is used here to give you an idea of the difficulty faced by shipping all during this time and the lack of preparation given to protecting not only people's lives but also protecting the value of goods and services these merchant ships brought to and from our young country. As an example, the Civil War was only a decade away, and we still were developing our own coast surveys determining the safe approaches to harbors and shipping safety up and down the coast.

The conformation of the coast from the eastern extremity of Long Island to Cape Fear has a remarkable and uniform feature. Along nearly the whole of this stretch of six hundred miles, except where interrupted by the New York, Delaware and Chesapeake Bays, the coast line is a strip of sand beach, from a quarter of a mile to five miles wide, intersected and broken into islands at varying distances by narrow inlets and separated from the mainland in most instances by long narrow bays. These beaches are constantly shifting, and at times advance considerably into the sea; the inlets also frequently change their position, and but few of them are navigable. Outside this cordon of beaches are numerous dangerous shoals, and all along it are bars of sand. Of this dangerous section of the Atlantic seaboard, the Long Island and the New Jersey coasts, lying as they do on each side of New

York, present a terrible record of disaster, and the beaches are strewn with the skeletons of wrecked vessels. The Government of the United States, like most Governments, was exceedingly slow to recognize the necessity of making some provision for the preservation of life on their Coasts.

From this one paragraph written in 1882, we get a glimpse of not only what our coastline was like 175 years ago, but also how dangerous it was for shipping. Civil engineer Beloe further evaluates our lifesaving service and the equipment used by comparing it to English versions. His paper would reach men of influence in England, and their opinions mattered. Poor evaluations could well affect trade, profits and tariffs, so reports such as this one reached many levels of government.

According to Beloe's report:

In 1848 the (United States) Government first gave its attention to the method of aiding stranded vessels by the establishment of stations, furnished with the means of effecting communication between such vessels and the shore. Under the direction of Captain Ottinger, eight stations were erected on the coast of New Jersey, and supplied each with a metal surf-boat, a metal life-car, mortars, rockets, &c. By 1854 one hundred and thirty-seven life-boats were stationed on the coast, including those belonging to the Humane Society of Massachusetts and the Life-Saving Benevolent Association of New York, a similar body founded in 1849.

In 1853–54 great loss of life took place through the inefficiency of the lifeboat service, and in the latter year an Act of Congress was passed authorizing the appointment of a superintendent for each of the coasts, and a keeper for each station, also the establishment of many additional lifeboat stations; but these were not erected. No provision was made for the employment of crews, the stations being dependent upon volunteers, often difficult to obtain on the sparsely populated coast. The service remained in this unsatisfactory condition until 1871, when many fatal disasters occurred within the limits of the operations of the service, and the circumstances showed beyond dispute that the loss of life was largely due to the want of proper attention to duty on the part of the officials, and the inefficient condition of the boats and apparatus; this was confirmed by a report from an officer instructed to inspect the stations, and a thorough reorganization of the service was determined upon. The removal of incapable and inefficient officers, and the substitution of suitable men; the repair of the stations, and their equipments; the employment of selected crews at nearly all the stations,

and the promulgation of a series of instructions, specifically setting forth the duties required of officers and men, were the first steps taken in order that the service might be placed upon as efficient a footing as possible for the approaching winter's work.

Measures were also taken for the establishment of as many additional stations as were necessary to bring them within about three miles of each other, where natural obstacles did not prevent, with a view of enabling each to summon, by process of signalling, its neighbours to its assistance when needed. The stations of Life-Saving Service are divided into three classes. The first class are intended for exposed localities, destitute of inhabitants, where crews to render assistance in rescuing the shipwrecked cannot readily be collected, and where the means of sheltering and succouring the latter are not at hand, and also for flat beaches with outlying bars. These stations are about 42 feet in length, and 18 feet in width, with a lower and upper storey, each divided into two rooms. One of the rooms below is appropriated to the proper arrangement of the boats, wagon, surf-car and other heavy apparatus; and the other is plainly furnished as a mess-room for the crew. One of the rooms above is intended for the storage of the lighter portion of the apparatus, and the other is provided with a number of cot beds and suitable bedding. This class of stations is established upon a portion of the Atlantic coast, and upon the Lake and Pacific coasts at a few points where such protection seems requisite.

Mr. Beloe comments on the methods of rescue, saying:

Having thrown the line over the wreck, the shipwrecked crew proceed, as in England, to haul on the line, to which is attached the tallyboard, with instructions how to proceed printed in different languages, also the tail-block and whip. The tail-block being made fast on board the ship, the surf-men haul on the whip and convey the hawser to the wreck; one end being made fast on board, the rope is carried over the crotch or tripod, and hauled taut by means of tackles secured to the sand-anchor; the hawser thus forms a sort of suspension bridge between the wreck and the shore. Various methods have been used for conveying persons from the wreck along the hawser, and until recently the department adopted the life-car, which is in effect a small covered boat, capable of holding from two to four persons, and suspended from the hawser by rings; the life-car has the advantage not possessed by any other contrivance of bringing women, children, and sick people to shore in

a dry condition, and without risk, and on some occasions bullion and other valuable property has been saved by its use.

Two hundred and one persons were saved by the car at the wreck of the Ayrshire, on the New Jersey coast. But it has its disadvantages; one being the inconvenient means its narrow hatchway affords in the commotion of the sea for receiving those who are to enter it; but the most serious drawback to its use is its excessive weight of 221 lbs., as compared with the 21 lbs. of the breeches-buoy; consequently the use of the life-car has been reserved for cases when large numbers of persons have to be saved, and when the crews of several stations have collected at the wreck, the breeches-buoy being taken first to the scene of action for the sake of speed. The life-car is the invention of Captain Ottinger, who received $10,000 from the Government for his invention.

Author's note: He got this wrong. The Francis Life-Car was patented by John Francis, for which he received money, and President Benjamin Harrison presented him the Congressional Medal in 1890.

There were one thousand nine hundred and eighty-nine persons on board these vessels (in 1854–55) of whom one thousand nine hundred and eighty were saved, nine only being lost; four hundred and forty-nine shipwrecked persons were succored at the stations, receiving in the aggregate one thousand two hundred and two days' relief. The total number of vessels lost was sixty-seven. The year 1880 is marked by a higher record of casualties than any previous year, and these services were not rendered without loss of life to the service, and the whole of one crew of six men perished by the capsizing of their boat, the keeper alone escaping, although the men wore the admirable life-belts introduced by our Lifeboat Institution. This sad event is another proof of the advantage of the self-righting boat, as these men would in all probability have been saved if their boat had been of that description, for they were all kept afloat by their jackets, but perished from cold during their long immersion.

As maritime traffic expanded in the early nineteenth century, especially with the rise in passenger travel, water safety became a top priority for American shipping inventors. This patented life-car was one of the first and most successful life-preserving devices developed at the time.

The Francis Life-Car was successfully used again off Squan Beach, but the vessel this time would be the packet ship *Cornelius Grinnell* on January

Remains of an early shipwreck were unearthed during construction of a shore seawall in Mantoloking and Brick. While unidentified, they may be part of the wreck of the *Ayshire*, lost in 1850. *Daniel Nee, http://brick.shorebeat.com/.*

14, 1853. Another storm limited the captain's ability to detect landmarks. Thinking he was safe and spotting a lighthouse he assumed to be on Fire Island, New York, he set his course only to find out the lighthouse was actually one off Sandy Hook. He wasn't safe and was far off course. All 270 Irish and German immigrants were brought safely ashore by means of the life-car. Historical note: The *Cornelius Grinnell* and the *John Minturn* were packet ships of the same line, and in fact, they were named after the shipping line owners.

The next use would occur on the wreck of the Dutch bark *Adonis*, wrecked off Long Branch on March 7, 1859. The rescue was going well until the hawser or line securing the life-car between beach and ship gave way. The car dropped into the water and would have potentially drowned the occupants were it not for the bravery and efforts of the surf man, who waded out into the surf and pulled the two-hundred-pound ship to shore, saving those aboard.

Over the next three years, this device rescued at least 1,400 people on the New Jersey Shore alone, as well as countless amounts of valuable cargo. Joseph Francis donated his original, groundbreaking life-car, which had been used in the *Ayrshire* wreck, to the Smithsonian Institution National Museum

of American History. Mr. Francis received a special Congressional Medal from President Benjamin Harrison and the applause of Congress, in addition to many international awards, for his invention, which revolutionized life saving. Eventually, the life-car would be retired and replaced by the more efficient breeches buoy for shore-to-ship rescues. The breeches buoy was a circular lifebuoy used by lifesaving crews to extract persons from wrecked vessels. Usually, a line is fired from a cannon onto the deck of the wrecked vessel. The line was propelled by the Lyle gun, a line-throwing gun that is a short-barreled cannon designed to fire a projectile attached to a rope to a ship or victim in distress. The line for breeches buoy is stored in a faking line box, which helps to keep the line fair and prevent fouling when the projectile is fired from the Lyle gun. This method was more efficient and enabled rescuers to help save people without needlessly risking their own lives.

Chadwick Beach Lifesaving Station was located about five miles from the top of Barnegat Bay, between Mantoloking and Lavallette. The site of the *Ayrshire* has never been found. As with many beach wrecks, shifting sands and ocean currents are constantly working to change shorelines. In later years, we added beach replenishment processes to natural ones, and perhaps not so oddly, it was this beach replenishment and rebuilding of our coastlines in

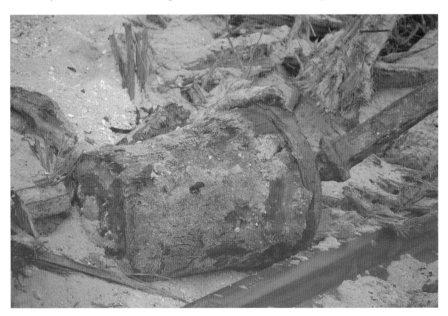

Pieces of wreckage from a wooden sailing ship dug up on the beach. Storms and beach construction unearth old shipwrecks from time to time. *Courtesy of Daniel Nee, http://brick. shorebeat.com.*

the Superstorm Sandy aftermath that caused wreckage of a wooden ship to appear on a Mantoloking/Brick beach. As contractors were digging up the beach to build a seawall defense against the next coastal storm, they unexpectedly uncovered the wooden remains of a ship. This discovery has raised some interesting questions and elicited further research. It could be nothing more than an old barge or even another sailing ship, but if it is indeed the *Ayrshire*, it has significant historical value.

According to Daniel Lieb, president of New Jersey Historical Divers Association and a noted local authority on shipwrecks, "If the remains are from a ship, they could potentially match those from one of twelve wrecks. One of these wrecks is the *Ayrshire*, a Scottish brig that went down after hitting a sandbar on January 12, 1850."

The sinking was historical because it marked the first time the Francis Life-Car was used, according to Lieb. The life-car, which saved 199 of the 201 British and Irish immigrants on the *Ayrshire*, was acquired by the Smithsonian's National Museum of American History Natural History. "The first time it was ever used, and it was used quite successfully," he said. "If this wreckage is indeed the remains of Ayrshire, that makes this wreckage highly historical, one of the most historical ship wrecks in the U.S."

THE *NEW ERA*: ONE OF THE GREAT TRAGEDIES ALONG THE SHORE

European immigrants continued to flow into the United States, leaving their native lands for better opportunities. In the fall of 1854, four hundred Germans were leaving their economically depressed homeland behind. It appears that many of the passengers had the means to make a better life for themselves and were far better off than the steerage immigrants often found on these vessels. Each carried whatever fortunes they had, as they had sold everything they owned to make better lives for their families and themselves. These immigrants were likely headed to Pennsylvania and the states surrounding it. Much of the story comes from the Pennsylvania-German Society of Lancaster, which published its account of the tragedy back in 1907. It remains one of the only complete accounts of the wreck. Of course, newspapers recorded the event at the time, but the more compelling tale is in the account from the Pennsylvania-German Society.

We have already read about the dangers of the New Jersey Shore. The coastlines were treacherous, with constantly changing sandbars, uninhabited

shores and little in the way of organized lifesaving. The maritime waters between Sandy Hook and Cape May Point have long been known as among the world's most dangerous. If there was ever a ship to master those waters, it seemed the newly built *New Era* might be it.

The *New Era* was built to carry passengers and was perhaps built just for immigrants. Her owners were the builders, Hitchcock & Company, and the captain, Thomas J. Henry, also owned a share. Some would later question the financial relationships with regard to the actions taken at subsequent hearings after the disaster.

The *New Era* sailed from Bremen on September 28, 1854, for the Port of New York, with a cargo of six hundred tons of chalk; about twenty thousand cubic feet of general merchandise, mostly dry goods and hardware; and a passenger list of 5 first (class) cabin passengers, 6 passengers in second (class) cabins and 374 in the steerage. The crew consisted of 29 persons and 12 passengers' cooks, making a grand total, including the captain, of 427 people. The *New Era* was consigned to the firm of Charles C. Duncan & Co., of No. 52 South Street, New York City. The vessel was heavily insured (Author's note: Remember, these are the dollars of the time in 1854): $10,000 in the Mutual Insurance Company, of Bath, Maine; $50,000 divided among six Boston companies; $25,000 in other Bath companies; and $6,000 in Wall Street, New York. If a wreck like this happened today these numbers would be $2,422,500 in 2015 dollars—a lot of money for the owners. It would be interesting to see if the claim was collected and for how much. It all depends on if the insurance company that held the claims is still in business or if it archived old records or neither. I've been to visit several Wall Street firms to research shipwreck claim and cargo data that cover these claims, and mostly all that is available is the cost for insurance or cargo value purposes. (Author's note: They never want to tell you they paid out a claim.) This kind of money can make people do strange things. But it's all speculation, isn't it? Owing to this heavy insurance, it was publicly rumored at the time that the ship was intentionally run ashore to get the insurance, which, it was believed, was far above the real value of the vessel and its cargo. It should also be noted that most all of the crew survived, while most of the passengers did not.

No images survive of the ship, which really wasn't unusual for the period. Photography was rare and just beginning; the earliest known photograph was taken in 1826. Paintings and illustrations from sketches were the normal route for ship portraits. Owners would usually commission paintings after the first voyage. As this was the first sailing of the *New Era*, perhaps she was carrying her own portrait back to her owners. We know she was built as a

clipper ship. There were many built during this period. They were built as a long, slim, graceful s with projecting bow and radically streamlined hull, carrying an exceptionally large spread of sail on three tall masts and long gracefully curved bow and graceful hull sweep sometimes referred to as the greyhounds of the sea. These types of ships were usually merchant ships designed for speedy passages. The 1,300-ton *New Era* was built along the Kennebec River in Bath, Maine, in 1854. Her trip east went smoothly, but things unfortunately would deteriorate from here.

Gale-force winds and rough seas soon developed as she sailed westward into the Atlantic, and needless to say, the conditions made her passengers seasick. As if that wasn't tough enough, a cholera outbreak midway across killed over forty people, who had to be buried at sea. Passengers noted that it was no better or worse than the average trip on a sailing vessel of that kind, in which so many people were huddled together for weeks in the smallest possible space without proper food, ventilation or sanitation. As a result, when the cholera broke out among passengers and crew members, the nature of the plague was kept quiet to prevent a panic. Some blamed bad water and lack of cooked food as a probable cause.

In 2015, the World Health Organizations defines cholera as an acute diarrheal infection caused by ingestion of food or water contaminated with the bacterium *Vibrio cholerae*. Researchers have estimated that every year there are roughly 1.4 to 4.3 million cases and 28,000 to 142,000 deaths per year worldwide due to cholera. The short incubation period of two hours to five days is one factor that triggers the potentially explosive pattern of outbreaks. Cholera is an extremely virulent disease. It affects both children and adults and can kill within hours. During the nineteenth century, cholera spread across the world from its original reservoir in the Ganges Delta in India. Six subsequent pandemics killed millions of people across all continents. This was scary stuff aboard a brand-new ship.

The Pennsylvania German Society of Lancaster, Pennsylvania, recorded the testimony of passengers, who complained of a "scarcity of provisions and what was available was often bad quality or under-cooked, so much so that the passengers took to hire cooks from among themselves." Their faith in the ship's doctor didn't appear to be any better. Passengers called him uncaring and often brutal in his treatment of the sick. It was turning into a miserable trip, and it would get much worse for everyone very soon.

Poor weather, it seemed, followed the ship from the outset of her voyage. The ship was well on her way to New York when she was hit by yet another terrible storm. The ship took on lots of water caused by the high waves

nautically referred to as "heavy seas," which were so large that they washed over the decks, taking away anything not secured—and even sweeping away the cook's galley. The waves caused great damage and killed several passengers, as well as straining the vessel to such an extent that she sprang several leaks and cracked seams, necessitating constant labor at the pumps. The captain utilized the passengers to man the pumps as the ship continually had four to six feet of water in her bilges.

According to weather archives, the fifth tropical storm of the year—or perhaps just remnants of the storm, which, by all indications, was severe—had a storm track that could have impacted the trip. This storm occurred October 20–22 and had sustained winds around seventy miles per hour, but it never made landfall and could have been in the path of the *New Era*. There is no way to know for sure, but the storm and location fit the events. The *New Era* sank on November 13, so it's plausible this storm added to the ship's miseries. (Author's note: The amount of information available to anyone who knows where to look never ceases to amaze. Not only does data exist about the storms back in 1854, but also Weather Underground on its website plots possible storm tracks.)

The *New Era* went ashore at Deal Beach, which itself had its share of shipwrecks, with no fewer than forty-four wrecks between 1800 and 1854. The *New Era* went ashore about six hundred yards or so off Deal Beach on Monday, November 13, 1854. The sea broke over the vessel as high as the first yardarm, which would mean twenty-foot waves or higher, and in less than an hour, she filled with water and sank. The volunteer lifesaving crew was quickly at the scene of the wreck with lifeboat, mortar and rocket line. Several attempts were made to launch the lifeboat, but owing to the wildness of the surf, every effort proved futile. To make matters worse, as the wind shifted, it and the waves swept over one hundred people into the raging water. Word of the wrecking spread quickly in the local community from Manasquan, and people began to show up, including onlookers, surf men and wreckers.

Accounts written by the Pennsylvania-German Society in 1907 survive the wreck and speak of the disaster from the point of view of the few remaining eyewitness survivors. While efforts were being made on shore, a boat was lowered and cleared away from the ship. Survivors commented that the boat was manned by the first and second officers and three of the crew, who started for the beach with orders to get a line ashore through the wild breakers. The crew of the boat, however, cast off the line, abandoned the ship and rowed ashore. Another boat was lowered, but hardly had it cleared

the ship when the cowards who manned it cut the line and saved themselves. The sailors heartlessly turned their backs on the wailing passengers. The last remaining boat, known as the "long boat" and intended to hold from forty to fifty persons, was then lowered over the side, and six of the crewmembers got in to bail her out. While they were thus occupied, the ship's surgeon, who had gathered up gold and silver coins belonging to the passengers, attempted to get into the boat. Weighted down as he was with his ill-gotten money, he capsized the boat. He was then crushed between boat and ship and swallowed up by the sea, never to be found. Poetic justice was served.

Hour after hour, the desperate multitude of ravaged passengers shouted and raved while the lifesavers on shore tried to shoot a line across the wreck from a mortar. Finally, a boat made it to the stranded ship. The captain got into the boat and was followed by some of the remaining crew members. The boat had capsized several times and was full of water. The captain ordered some of the crew to bail her out, and then he cried out to the people to haul the boat ashore. Ten or twelve of the passengers jumped in after the captain and attempted to get into the boat. They were beaten back, and all drowned but four, who fought their way into the boat. The people on the beach now hauled the boat toward the shore, but she capsized three times along the way. Only the captain, three of the crew members and one passenger, who had clung to the keel of the boat, were saved.

News of the disaster had been telegraphed from nearby Long Branch to New York early in the morning. This news was immediately conveyed to Captain Reynolds of the steamer *Achilles*, which was then lying off Sandy Hook. When he heard that the lives of three hundred passengers were imperiled, he set out immediately to search for the stranded vessel. Owing to the density of the fog and the rough sea, it was not until 8:00 p.m. that the steamboat found the *New Era* off Deal Beach. By that time, she was full of water, and swells were breaking in heavy surges across her decks. The rigging was filled with human beings, closely packed together and clinging to one another and to the ropes as the ship surged to and fro with each returning wave.

The *Achilles* didn't have lifeboats, surfboats or life preservers, so it couldn't do anything to help the despairing Germans on the wrecked vessel. The steamer stood by but was unable to approach near enough to be of service. Unfortunately, even communication could not be established, as there was no one on the wreck who could understand English, and no one on the steamer who could speak German. In the meantime, another steamer, the *Leviathan*, arrived from New York but, like the Achilles, had no apparatus

or means of rendering any assistance. Still later, the tug *Hector* came into sight. No attempt, however, at rescue was made, and the *Achilles* and *Leviathan* returned to New York. Thus the emigrants aboard the ill-fated ship were seemingly abandoned by the would-be rescuers on both land and sea.

However, before the break of day on the fourteenth, more volunteers had arrived. Also, both the seas and winds had calmed somewhat, enabling the ship to be boarded by the use of lines from shore, and 135 passengers—most, if not all, of them men—were safely landed, though 3 of them died shortly after reaching shore, most likely from exertion and exposure to the cold and sea. These few men were all who were left alive out of the almost 400 passengers aboard when the ship sank. As the bodies washed ashore, they were gathered and taken to Abner Allen's boardinghouse until the coroner could hold an inquest. Mr. Allen was also a volunteer keeper at the Deal Lifesaving Station. Since most of the bodies could not be identified unless they had some personal item that could be attributed to them and some in such poor condition only added to the confusion, they were merely numbered and a description taken by the coroner. After this was done, each body was placed in a rough wooden box (for which the coroner charged the county seven dollars) and buried in a common grave in the little Methodist burial ground between Long Branch and Eatontown.

The society report mentions a news correspondent who wrote that he saw the ship and investigators, led by Captain Bowne, shortly after the passengers were rescued:

> *The ship lay about 300 yards from the shore, on the outer bar, her deck level with the water, and the sea washing over her continually. At the period of which we write, it was about low water. There is no chance of saving anything from her beyond her rigging. The masts were standing uninjured, and with the exception of the loss of mizzen-top-gallant, she appeared to have suffered no damage above the bulwarks. In the main shrouds of the sails, the body of a female was still visible, nearly nude, her arms and legs thrust through the crossings. The planking of the bulwarks was all torn off, and the sea belched every moment through the frame of the bulwarks, like the smoke from a frigate's guns when firing a broadside.*
>
> *Long after the survivors had been rescued we were invited to go on board. We took a seat in the surfboat, and were soon rowed through the breakers and alongside the ship's quarter. Watching an opportunity, as a spent wave receded, we leaped into the rigging. Such a spectacle as the decks of the* New Era *then presented we hope never to be called to witness again. The*

forecastle was beaten in, and the top of the cabin on the larboard side had a large hole in it that the waves had made. The deck had been swept of everything. The frames of the bulwarks stood above the waves, while protruding through them were the bodies of men, women and children, all of them naked, or partially covered with the clothes they had on when asleep in their berths. But the most awful sight of all was directly below our feet. There, between the side of the poop-cabin and the mizzen chains about a score of corpses, all stark, stiff and cold, lay in every conceivable attitude of agony, maimed, crushed and bruised, with eyes washed from their sockets, with teeth set like vices, and every feature fearfully convulsed; there, promiscuously heaped together, were old men whose race had nearly run; young maidens, just blooming into womanhood, and babes whose lives were measured but by weeks. Every age and sex had its representative here, and told in ghastly types how much humanity may suffer. The blood had frozen into blackness beneath their finger-nails, and with the half-clenched hand, showed how strong had been the grip upon the rigging—how long and fierce the strife for life; a contest in which they did not yield until the bleak blast had frozen their hearts' blood, and their unconscious hands had loosened their grasp, when their lives went out in the dark night, swallowed up beneath the seething waves that burst madly over the ship. And let us here remark, that until we came on board, the sea had been so rough, and the tide too high to venture from the shore, else these remains of the poor strangers would have been taken ashore and prepared for interment. As it was, Captain Bowne ran along the top of the bulwarks to the main rigging, to take down the body of the woman that still remained there. With some difficulty, he disentangled her stiffened limbs from the shrouds, and gently lowered her by a rope into the surfboat.

Sadly, the article does not give credit to this anonymous journalist. It was most dramatically written and had to be a terrible experience for the reporter and everyone on the boat, but it so monstrously sums up the terror of the day.

In this disaster, 295 persons lost their lives. Buried in a local church cemetery were 240 of the victims, and 12 others were buried elsewhere. Though 3 would die from injuries or shock, 135 survivors—mostly men—were brought ashore. One woman gave birth to a baby boy shortly after her rescue. Survivors were cared for locally, many at the Allen home. They would later be sent on to New York City and then on to their ultimate destinations.

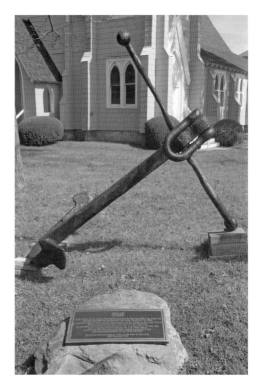

Right: The anchor of clipper ship *New Era* rests on the corner of Elberon and Norwood Avenues (Route 71) in Allenhurst, New Jersey. *Author's collection.*

Below: This memorial plaque is dedicated to the victims and to Abner Allen, the first rescuer on the scene. *Author's collection.*

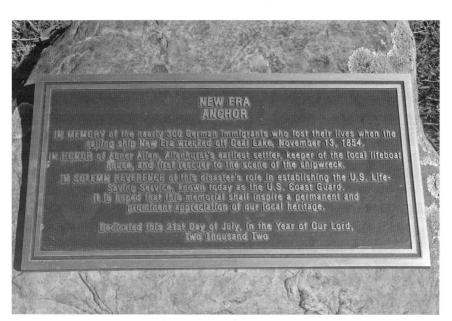

NEW ERA
ANCHOR

IN MEMORY of the nearly 300 German immigrants who lost their lives when the sailing ship New Era wrecked off Deal Lake, November 13, 1854.
IN HONOR of Abner Allen, Allenhurst's earliest settler, keeper of the local lifeboat house, and first rescuer to the scene of the shipwreck.
IN SOLEMN REVERENCE of this disaster's role in establishing the U.S. Life-Saving Service, known today as the U.S. Coast Guard.
It is hoped that this memorial shall inspire a permanent and prominent appreciation of our local heritage.

Dedicated this 21st Day of July, in the Year of Our Lord,
Two Thousand Two

James Bradley, who would become the founder of Asbury Park, built a monument to this disaster in 1893. In 1894, there was a storm, and the monument toppled into the ocean. It hasn't been seen since. The ship's massive anchor, discovered in 1999, now sits at the corner of Elberon and Norwood Avenues in Allenhurst, along with a plaque memorializing the victims. A large wooden section of what is believed to be the *New Era* recently was found off a jetty in Asbury Park.

In April 1854, the *Powhattan* wrecked on Long Beach Island. The *Powhattan*, a paddlewheel steamship of 900 tons, was wrecked by what was likely a nor'easter spring storm, with driving snow and freezing temperatures. A story written by the *New York Times* on April 22 of that year quotes wreck master Edward Jennings as he watched and could do nothing to help, as the seas were monstrous. Horribly disfigured bodies washed ashore in great numbers, and he along with the gathering onlookers and volunteers witnessed a huge wave—at least one hundred feet tall—that smashed over what remained of the wreck, utterly destroying it. In a few minutes, all but a few pieces of the shipwreck disappeared beneath the waves and soft sands.

Jennings would later say, "Never did I see such a sight in my life. Never do I remember witnessing such a dreadful gale or such a high-running sea. In many places it made complete breaches over the island and carried, no doubt, many a poor fellow into the bay behind it."

The death toll would exceed 250 persons, and men, women and children were killed. Initially, 75 bodies washed ashore about a mile south of the wreck site. Eventually, over 130 bodies would be washed ashore, and the wind and seas spread the dead along a twenty-mile section of the coast. The bodies washed ashore from Absecon Island to Brigantine Island and some even on Long Beach Island. Many of those bodies recovered were buried in a mass grave in what would become Manahawkin Baptist Church. Outcries would be made to adopt safety measures for the protection of human life on the seas. Many ships wrecked on Absecon Island beaches—in fact, sixty-four ships sank in a nine-year period from 1847 to 1856—but it was the loss of the *Powhattan* that caused the Congress of the United States to erect the Absecon Lighthouse in Atlantic City. As we will read in the next chapters, disasters at sea continue, and though they now happen more at the hands of people than as a result of storms, they are nonetheless dramatic and costly.

The losses of these three wrecks highlighted in this chapter helped build more lifesaving stations along the coast, which would be located closer to one another and staffed by qualified and trained surf men with budgets for daily operations. The Francis Life-Car showed how new technology could

U.S. Life Saving Station Number 4 off Monmouth Beach was built in 1849 and is the second one in New Jersey built after the tragedy of the *New Era* wrecking. *Author's collection.*

be developed to help save lives, and it was realized that one organization should be responsible for managing the lifesaving efforts for not only New Jersey but eventually all coastal states. They are by no means the only such shipwrecks. Wrecks covered the many miles of the Jersey shore during the nineteenth century. Over the years, I have researched and dived many of them. Their stories add to the maritime history of New Jersey.

The shipwrecks of the *Rusland* and the *Adonis* are referred to as dual wrecks by local scuba divers, as they lie on top of each other. This happened when the 550-ton bark *Adonis* ran aground and sank, with twelve crew members, during a winter storm on March 8, 1859. Ten years later, a similar storm forced the steamship *Rusland*, carrying two hundred passengers and crew members, toward the beach, striking the submerged remains of the bark *Adonis*. This collision caused the *Rusland* to sink on top of the *Adonis*. There were no casualties from either of the wrecks. These used to be beach dives, but they now lie farther offshore and require a boat to dive and explore.

Other ships that went to wreck along the Jersey shore include the *Pliny*, a 1,600-ton steamship sunk on May 13, 1872, that now lies off Deal Beach. The *Meta* (often referred as the Mantoloking Wreck) was a sailing ship of

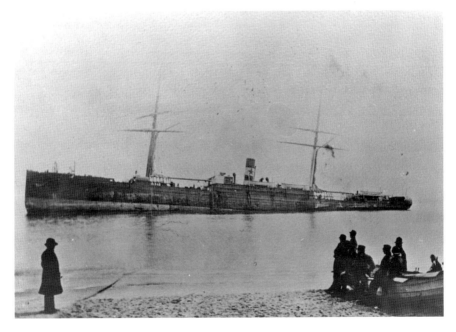

The steamship *Rusland* is pictured aground at Long Branch in 1877. *Mariners Museum.*

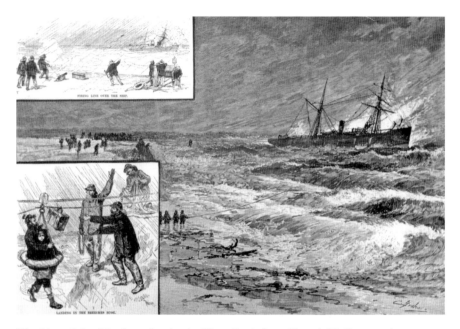

Wrecking of the *Pliny* from sketches by Theo Davis from *Harper's Weekly* magazine. *Mariners Museum.*

1,800 tons that ran aground in fog with no casualties, and its remains are so far unidentified. The *Amity* is often referred to as the Manasquan Wreck as it lies off the town of Manasquan and inlet, about one hundred yards off the beach. The *Amity* was the second ship of the Black Ball Company and the first to offer scheduled transatlantic voyages. The *Amity* ran aground in a fog with no casualties but suffered loss of cargo on April 24, 1824. It is one of the earliest known shipwrecks.

The *Chauncey Jerome* was a packet ship of the Blue Ball Line that ran aground in 1854. The wreck lies off what is now Seven Presidents Beach in Long Branch, New Jersey. It is listed on the National Register of Historic Places. Years ago, pieces of it could be seen at dead low tides. Beach replenishment and storms have changed all of that. It may well be lost forever, but perhaps with a storm similar in ferocity to Superstorm Sandy, one day the winds and waves will reveal what lies beneath the beach dunes. Only time and the next storm may tell for sure.

The list of shipwrecks in these waters is seemingly endless. Off Squan Beach alone between the years 1704 and 1900, over 120 vessels were wrecked. Some have been chronicled here, but others have yet to be identified. Most are probably buried under twenty to thirty feet of sand—if

This large artifact is a capstan, used to haul the anchor recovered from the *Chauncy Jerome, Jr.*, a ship that wrecked off Long Branch in 1854. *Photo from author's collection. The capstan is part of a collection held by the New Jersey Historical Divers Association in Wall, New Jersey.*

they even exist any longer. How many ships have been wrecked, no one truly knows, and unless there were witnesses who recorded these events, we may never know the stories. The stories of losses of the *John Minturn*, *Ayrshire* and *New Era* have changed how we rescue shipwreck victims and how we would try to safeguard people in the future.

Chapter 4

THE MULLICA RIVER SHIPWRECKS AND THE REVOLUTIONARY WAR

New Jersey has commonly been known as the "Crossroads of the American Revolution." So many of the major Revolutionary War battles were fought here at places that jump off the pages of our history textbooks, like the Battles of Monmouth, Princeton and Trenton and, of course, the iconic Delaware Crossing on Christmas Day by General George Washington in 1776. Washington and his main army, it seems, had spent more time in New Jersey than any other place. Of course, New Jersey's geographic position between New York and Philadelphia was a large part of that "Crossroads" title. Not surprisingly, the ocean provided another type of crossroad—one that was faster, more direct and with the ability to send large amounts of supplies and troops by sea and along our coastline.

All of this makes the following tale all the more interesting. In the late 1700s, southern New Jersey was largely uninhabited. Long Beach and Absecon Islands were simply barrier islands, home to the occasional fisherman, Indian or a hardy settler. Atlantic City wouldn't become a town until 1854. The South Jersey coastline was an ideal location for smuggling and privateering. I'm sure the British simply called the residents "pirates." South Jersey notable residents Richard Somers, John Cox and Richard Wescoat all were engaged in privateering. Colonel Somers's ships would occasionally supply the Continental Congress with gunpowder, shot and flints imported from the West Indies via his port in Somers Point. Cox and Wescoat worked the iron bogs at Batsto and saltworks along Great Bay. Cox and Wescoat would figure in the

upcoming Battle of Chestnut Neck on the Mullica River or, as it was known then, Little Egg Harbor River.

Southern New Jersey and especially its coastal sections played an important yet largely unknown—or perhaps just an untold—part in the fight for independence in the Revolutionary War. In his book *Nest of Rebel Pirates*, Franklin W. Kemp was one of the first to write about this. It's the story about Chestnut Creek, which was a small settlement along the river in 1778. The settlement would eventually become the town of Port Republic. But that's all part of this tale.

Colonial privateers operated out of the tiny inlets along the South Jersey coastline. These small, quick, privately owned and operated sailing ships would sneak out Great Egg Inlet and raid the British merchant ships moving material and products along the coast. Colonial privateers were issued letters of marque by the Continental Congress authorizing as many as 1,697 privateers during the American Revolution. The privateers from Little Egg Harbor were in a good position to attack merchant ships traveling along its coast. The cargos were then sold and the proceeds divided up by the government's Court of Admiralty. The ships' owners, captains, crews and, of course, the government all got specific shares, regulated by a Colonial Admiralty Court.

Along the South Jersey coast, these sales took place at Chestnut Neck (a small village at the mouth of the Little Egg Harbor River, now the Mullica), the Forks (a larger settlement farther up the river) and at Mays Landing (on the Great Egg Harbor River). Large warehouses were built to hold the cargos while they awaited sales and shipment. This entire area was important to the colonial forces as bog iron in Batsto was forged into cannon and shot and other iron materials for the Congress. The men who worked these iron bog furnaces were so important that they were immune from required service in the colonial militia. Also around Great Bay were numerous saltworks. Salt was a highly prized commodity at a time when vast quantities of food needed to be preserved for use by armies and aboard ships.

The settlement at Chestnut Neck was prospering from privateering operations, but the privateers knew it was only a matter of time before the British would strike somewhere to try to stop the loss of their merchant ships from these "pirates," as the British commanders called them. To protect themselves and their operations, in 1777 the privateers erected a fort at the water's edge to keep Chestnut Neck safe and also prevent the British from attacking Batsto Iron Works, which was a valuable asset for Continental forces. Richard Wescoat provided the funds to build the fort.

A typical merchant ship of the time period turned privateer and likely the type of ship at Chestnut Neck. *Naval History and Heritage Command. www.history.navy.mil.*

Oddly, the fort and the platform atop the hill behind it never had cannons installed, even though placements were made for them. It would prove to be a costly omission, as their presence would have made a contribution in the upcoming battle.

By late summer of 1778, about thirty ships and their cargos were sold at both the Forks and Chestnut Neck. Six more ships were sold off in September at Chestnut Neck. These were a huge loss for the British, and this was probably the last straw for the British. In New York, General Clinton and Admiral Gambier decide to organize an expedition to wipe out the privateering operations at Little Egg Harbor and destroy the ironworks at Batsto. The British would know the expedition as "The Egg Harbor Expedition." Word leaked out—probably through sympathizers—to the Patriots about the British fleet to destroy the privateers, and a militia issued a warning to coastal communities of this pending expedition. But while the threat was known, the specific destinations were still unknown. Late on the evening of September 30, Commander Henry Colins, on the newly commissioned HMS *Zebra*, and fifteen other ships left New York Harbor. A

storm and heavy seas slowed the fleet's progress, but they arrived at Little Egg Harbor Bay on October 4.

Because of the warning by colonial sympathizers in New York, several of the larger ships at Chestnut Neck were able to put to sea before the British arrived. Other vessels were sent farther upriver. The British reached Chestnut Neck on October 5, 1778. Light ships of shallow draft were able to set up a blockade of the bay to prevent escaping privateers, but without knowledgeable local pilots, their sail upriver was slow. At daybreak on October 6, the attack began. By late afternoon, the better-armed British forces routed the small militia at Chestnut Neck. British cannons and overwhelming numbers of men forced the small militia and the settlement residents to withdraw. Had the fort possessed and used cannons the outcome would surely have been different.

Commander Colins found ten prize vessels still at Chestnut Neck. He ordered the town and all the vessels to be dismantled, set afire and the ships scuttled. It took all night and until noon on the seventh. Colonel Ferguson, under General Clinton's command, decided to take his soldiers to raid the north shore of Great Bay and the saltworks. They destroyed two landings, three saltworks and ten buildings owned by Patriots. Having taken care of destroying the settlement, it was time to leave—but it was not as easy they might have hoped. Two of the British ships were aground. The HMS *Zebra* also ran aground, and the British could not get her free. On October 21, 1778, the British set fire to her and watched as her magazines exploded the ship to pieces. It was somewhat of a disappointment that the British lost a new warship while only partially achieving their mission to eliminate the rebel pirates of the Mullica. Chestnut Neck continued to operate privateers after this attack, but the settlement was not rebuilt, nor did its residents ever return, having fled to the inland villages. The area would later become the town of Port Republic.

Fast-forward to 1985, when maritime history experts and divers discovered the remains of two ships that were sunk by the British in the murky Mullica River during the Revolutionary War. The Atlantic Alliance for Maritime Heritage Conservation surveyed, mapped and photographed the river-bottom locations of the ships. The sites of two submerged ships had been pinpointed years earlier and are listed as Mullica River/Chestnut Neck Archaeological Historic District (ID#385) on the National Register of Historic Landmark Sites, but the divers reported that they had found two more wrecks and may have found a third. It's possible that one of the wrecks was a British merchant ship while the other was a two-masted sloop,

which is believed to be American. The discovery of this wreck and perhaps others still undiscovered in the silty waters of the Mullica will provide new information on American shipbuilding in the colonial period as archeologists have opportunities to examine the wreckage.

Researchers from Stockton University's Marine and Environmental Science Research Field Station, located on Nacote Creek, were surveying the river looking for abandoned fish pots or, as they are often called, ghost pots. In the course of their mapping, they recorded side-scan sonar images of several wrecks buried in the mud along the banks of what was the Chestnut Neck area. Are these the burned vessels, and is one of them the HMS *Zebra*? Their interest piqued after finding these shipwrecks, researchers from Stockton University continued their search—only to uncover two potential targets farther upriver that match the age and construction of the Revolutionary War prizes. What a great ending to a tale seldom told for over 230 years!

ABOUT THE MULLICA RIVER

The Mullica River headwaters originate in central Camden County near Berlin. Most developed land and upland agriculture is found in the headwater areas of the Mullica River. The river then flows for about 81.4 kilometers (50.6 miles) across Atlantic, Ocean and Burlington Counties and drains into Great Bay. The Mullica River Watershed covers 1,474 square kilometers of the Mullica River Basin. The unconfined Kirkwood-Cohansey aquifer system underlies the Mullica River Basin. The river flows generally east-southeast across the state, crossing the Wharton State Forest, where it receives the Batsto, Wading and Bass Rivers. Mullica broadens into a navigable river for only approximately 32 kilometers (20 miles) of its entire length.

The estuary of Great Bay or Great Egg Harbor Bay is considered one of the least-impacted marine wetlands habitats in the northeastern United States, due to the fact that most of the land in the Mullica River watershed is preserved or sparsely developed state-owned pine forests and scrub land and various wildlife management areas. In fact, the Mullica flows almost entirely within the Pinelands National Preserve. The Pinelands is classified as a United States Biosphere Reserve and in 1978 was established by Congress as the country's first National Reserve. The reserve occupies 21 percent of land area of the state of New Jersey.

A view of the Mullica River from the Garden State Parkway, near the site Battle of Chestnut Neck. *Author's collection.*

Where a freshwater river meets the salt water of the ocean is called an estuary. This productive estuary supports a diversity of fish species, including striped bass, flounder and bunker. It contains nesting habitat for ospreys, bald eagles and myriad other bird species usually found in marine wetlands and marshes. It is an important nursery area for the region's blue crab and hard-shell clam fisheries. Tidal creeks also support populations of the northern diamondback terrapin, which is listed by the federal government as a species of special concern.

Much of the area where the Mullica emptied into the Great Bay is part of the Edwin B. Forsythe National Wildlife Refuge as is the Jacques Cousteau National Estuarine Research Reserve (JCNERR). JCNERR is one of the twenty-eight national estuarine reserves created to promote the responsible use and management of the nation's estuaries. Great Egg Inlet—like the Great Egg Bay—was named for the vast amount of birds' eggs found by the early European explorers from the thousands of migratory birds that enjoy the marshes and warm-water nurseries that the estuary supplies. Both the Edwin B. Forsythe National Wildlife Refuge and the Jacques Cousteau National Estuarine Research Reserve are important ecosystems for the shore.

Chapter 5

TREASURE AND SHIPWRECKS

When people find out that I am a shipwreck diver, they invariably ask if I have found any treasure. The answer is always complicated because "treasure" depends on your point of view. I know they mean the kind of treasure they see in the movies, such as gold bars or coins, silver and jewels. The answer is "yes, but…" In the thirty years of diving the shipwrecks off the New Jersey coast, yes, I have found some pretty cool stuff, though certainly not in the quantities that would make me rich. The gold is usually gold-plated personal effects that crew members or passengers left behind when they abandoned ship. Once I did find a gold chain, but that turned out to be dropped by accident by someone on a fishing boat reaching for the net to scoop up a fish, and I even found a gold Rolex that fell into the boat slip. I gave both back. This doesn't mean that treasure isn't around. If you look up the definition of treasure in the dictionary, you will see the word can be a verb or noun. I have found lots of verbs and only a few nouns. Let me explain.

Shipwrecks often contain artifacts, which could have been cargo, personal effects of passengers and crew members or pieces of the vessel. If you are knowledgeable about ship construction and history and lucky, you can find all sorts of items that have value. Sometimes that value far exceeds that of gold and silver, and more importantly, it is easier to find! Collectors will pay well for a piece of a ship or an artifact from one. Of course, its condition helps increase its value, so an artifact can't be broken or misshapen like it might have melted in a fire or with any

These decorative perfume bottle toppers are artifacts recovered from the *Mohawk*. It's hard to image a wreck so thoroughly destroyed could produce things still intact. *Courtesy of Rich Galiano.*

other type of damage that could decrease value, like erosion from the sea or scratched metal. A ship's porthole, for example, is made of heavy bronze or brass metal with a leaded-glass window. They sell as antiques to nautical collectors for $400 or more. I've heard of old sailing ship stock anchors—the kind you see in front of seafood restaurants along the New Jersey shore—that sell for upward of $3,000 each. They are difficult to bring up off the seafloor, as they usually weigh two thousand pounds or more, but if you have a buyer who really wants something authentic in front of his or her establishment, it would be worth the effort. Some of the bottles I've found on older wrecks have value because so few are around and they have become scarce. Types of spring water bottles sell for upward of $500 a piece. Here, color, size and brand name determine value. Inkwells and poison bottles, of all things, are very valuable. My wife and I once uncovered several cases of umbrella inkwells, packed in the original crate dating back to the Civil War. They could sell for $100 to $200 each. We gave them away as souvenirs. Who knew? The phrase

"one man's trash is another man's treasure" certainly applies to artifact hunting on shipwrecks.

Spanish or Portuguese treasure galleons had to get really lost to find themselves off the New Jersey coast; we just weren't on their way to or from where they found the gold. We are, however, part of one of the busiest seaports in the world in the Port of New York/New Jersey. Every year, over four thousand ships enter the harbor, which handles well over three million cargo containers for a revenue of $200 billion. For centuries, more than a few of those ships found their way to the seafloor as shipwrecks.

Powerful hurricanes and nor'easters occasionally produce artifacts secreted in the buried wrecks along a beach. Metal detecting has long been a popular pastime by treasure-hunters along beaches, looking for rings or money left behind by beachgoers and, on rare occasions, something worth a whole lot more. Off Sea Girt at the south end of the boardwalk and in front of a rock groin, a friend mentioned that she had found a silver doubloon or piece of eight, which used to be currency of the Spanish realm. Curious, I researched the area for possible shipwrecks, and finding none, I enlisted my friend Vince Capone, who is an internationally recognized expert in sonar use and interpretation. We grabbed his sonar and my boat and started mowing the lawn off Sea Girt beach. "Mowing the lawn" is a term used to illustrate how you follow a path up and down over a specific area to sonar search for targets, just like the back-and-forth process of mowing your lawn. I made all that sound easy, but Vince takes a long time to be convinced to spend his time and use his $90,000 sonar on mere whims. He teaches the United States Navy how to use theirs. Needless to say, I owe him lots of favors.

We scanned a depression in the seafloor about five hundred yards off the beach that wasn't consistent with the rest of the area's topography. While we were sort of sure we had a possible wreck buried deep in the sand, we weren't positive, so we brought in Gary Kozar, who runs Klein Sonar Systems, to take a look at our data. He confirmed that the depression is evidence of a buried wreck. He thought that, based on the depression size, the wreck is deeply buried. The wreck lies northeast of the southern end of the boardwalk—the perfect path for a nor'easter to churn up the sand and move it and what's under it inshore. The wreck is too deeply buried to be effectively worked, and it lies offshore of some very wealthy homeowners who would probably not like having their ocean view disturbed by a barge and all sorts of equipment during the summer. But we know something is there—just what remains to be discovered, but apparently it occasionally offers up silver doubloons. It's definitely a treasure wreck.

SS *DELAWARE*

The *Delaware* was a coastal steamship whose normal run was from New York to Charleston or Jacksonville and, on occasion, Havana, Cuba. She would stop at various ports along the way, depending on cargo or need. These types of vessels were often called "tramp" steamers, as they also carried passengers along with cargo at reduced rates (Author's note: at least from the more expensive passenger lines) and made more leisurely sails with destinations often a surprise along the way. This suited many travelers who found the trips pleasant and inexpensive.

The *Delaware* was operated by the Clyde Lines Company out of New York City. Clyde Lines, established in 1844, would eventually merge with Mallory Lines in 1932. Together they would lose several ships along the New Jersey coast until both companies faded from existence. The *Delaware* was built at the Hillmans Yard in Philadelphia. She was 1,646 gross tons, 251 feet long with a beam of 37 feet and powered by a single-piston steam engine. She carried sixty-six passengers and crew members who lived within her three decks. The vessel itself was insured for $125,000, while her general dry goods cargo was also insured for roughly the same amount. There have always been two persistent yet unqualified rumors about her. One was that she was carrying ammunition, presumably for the soldiers and sailors fighting in the Spanish-American War, and the other rumor—more of interest to divers—was that she carried a strongbox full of coins worth over $250,000, payroll for those same soldiers and sailors. It seems a coincidence that her insured value would be the same as the purported amount of cash in a strongbox that no one has seen or recovered to this day.

Her voyage began on a late afternoon on Friday, July 8, 1898, as the steamer left her pier and out onto calm seas. She quietly passed through the minefields at the entrance to New York Harbor and proceeded south along the New Jersey coast. The country was involved in the Spanish-American War during this time, the USS *Maine* had been blown up in Havana Harbor in February 1898 and precautions like the minefield seemed prudent. After 10:00 p.m., a few miles from Barnegat Light, a crewman reported smoke coming out of a hatch. Officers made a hurried investigation, but it was soon evident that the crew had a difficult fire to deal with. Holes were cut in the decks and hoses inserted, but the heat beneath the decks became steadily more intense. When finally the men got to work in the saloon, rolling up the carpeting and cutting through the deck, the smoke came through in such overpowering masses that it was deemed time to wake and notify the

The Clyde Line steamship SS *Delaware*. *Courtesy of the New Jersey Maritime Museum.*

passengers and prepare for the worst. Passengers were hurriedly taken off ship by lifeboat. There was little time to grab possessions.

According to facts reported by the *New York Times* in its July 10 edition, the *Delaware* had been about ten miles off Barnegat when the fire was discovered. She had at once headed in for the beach and was now about two miles off shore. The fire had broken through and lighted up the surrounding waters, while rockets were being sent up to attract other vessels and the lifesaving stations, which, on account of the war this year, had been on continued duty during the summer months for signal purposes. Some of the passengers said they heard explosions, and because of the rumors, they were sure there was ammunition aboard, but the officials of the company denied this and believed that the passengers, in their nervous fright, got exaggerated impressions of the noises of combustion going on aboard the ship.

Meantime, the wreck masters of the Cedar Creek Life Saving Station had noticed the distress rockets, and a surfboat was put off to the rescue and the steamer's crew members were launching their own lifeboats. The Cedar Creek surfboat relieved some of the boats of their passengers; the

fishing smack *Samuel B. Miller* of New York, which was nearby, took all of the occupants of one lifeboat. Around 2:00 or 3:00 a.m., the tug *Ocean King* arrived and took passengers from the other boats, anchored her own barges and took the stranded passengers back to New York.

The Merritt-Chapman Derrick and Wrecking Company dispatched the wrecking tug *W.S. Chapman* down the coast and arrived at the scene on the morning of July 9 and made ready to tow the derelict hulk of the *Delaware*, which miraculously was found still afloat and unfortunately still burning, despite the heavy rain of the morning. A dense smoke came from her as the rain inter-mixed with the burning ship. One mast was still standing. Nearly all of her hull above waterline was gone. A cable was made fast to her, and she was taken in tow, moving very slowly up the coast. She got no farther than offshore the town of Point Pleasant. Observers ashore, of whom there had been thousands in the course of the day, noticed that the tow had stopped, and soon afterward, the wrecking tug was noticed steaming speedily north. She had dropped her tow, which had dropped out of sight beneath the waters.

The *Delaware* is a favorite wreck site for New Jersey divers. It is one and half miles from the inlet and in seventy feet of water, making it easy to get to. Customers, in fact, often complain of being dumped on this spot because it is very close to shore, instead of diving offshore to more interesting wrecks. On days where the seas don't allow for those offshore dive trips, the wreck is convenient for a captain to make the charter and get paid. It is sometimes referred to as the "money wreck" for this reason. And those rumors about treasure still draw the curious explorer. The wreck is large and easy to navigate, but her remains are whatever was left below the waterline. The bow, which lies to the south, contains a huge pile of anchor chain (her anchors were salvaged many years ago, for one of the local retail establishments, as a matter of fact). As you swim past the bow, you can still see her winches, her boilers and then the fifteen-foot-tall single-piston steam engine. Finally, divers can follow the propeller shaft and large steel propeller at her stern covering a few hundred feet.

Digging anywhere on the wreck can produce artifacts. With the hurried departure of crew members and passengers, all of their personal possessions are probably still there. But, ask yourself, if you were told you had to evacuate the ship right now, wouldn't you grab all of your valuables, knowing the ship was burning and ultimately would sink and you would never see those things again?

I have found bullets, Indianhead pennies and occasionally other items of value. I've heard but not seen that gold coins have come off the wreck.

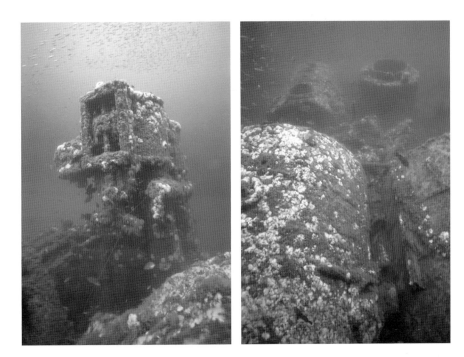

Left: The engine of the shipwreck of the *Delaware*, a wooden-hulled steamship. It is one of the most visited artifact wrecks off the New Jersey coast. © *Herb Segars, gotosnapshot.com.*

Right: An underwater view of the boilers on the Delaware. © *Herb Segars, gotosnapshot.com.*

Did the *Delaware* actually carry $250,000 in a strongbox? Of course the steamship company would deny this, wouldn't it? If the company admitted to carrying money in that amount, its ships would be automatic targets, so of course, it was kept quiet. Nothing of record indicates there was money onboard, and no public attempt was made to salvage the wreck. Did that mean someone carried it off during the mêlée of the fire and evacuations? The *Delaware* still remains listed as a treasure ship. Gold coin in the amount of $250,000 in 1898 would be worth over $7 million today, so divers will still make an attempt to find anything of value. Wouldn't you?

THE *SINDIA*

I've always been partial to china. Nothing like finding a perfectly intact piece of china on a shipwreck that has crashed, flipped, burned and sunk. It's so improbable that it makes it so valuable. It's one of the iconic artifacts from a

shipwreck. I have a collection of passenger liner china, from the *Andrea Doria* to an old Alaskan steamship back in the gold rush era, and not to mention finding several hundreds of dishes on wrecks along the New Jersey coast. We will occasionally use them for breakfast or dinner. There is nothing like eating off history! You probably do the same when you have Thanksgiving dinner on your great-grandma's china; mine just came from a shipwreck.

If you have ever visited Ocean City, New Jersey, you may have heard of the sailing ship called the *Sindia*. Much of the town had built its tourism around the wreck. A person used to be able to see the wreckage at low tide one hundred yards or so offshore, but no longer, as storms and beach replenishment have almost totally covered the spot.

The bark *Sindia* was 392 feet long and displaced four thousand tons. The ship had been built at the Northern Ireland shipyard of Harland and Wolff and was one of the largest sailing ships of her time. The *Sindia* ran aground on December 15, 1901, during a raging four-day gale that battered the ship with seventy-plus-mile-per-hour winds and mountainous seas. The gale winds whipped the seas and drove the bark onto the beach, finally succeeding in breaking her hull. Seawater and sand poured in and filled the ship. Successive waves pounded her until she started to break up.

Almost immediately, salvagers started to remove her cargo of fine silks, screens and matting. The Sindia also carried over three thousand crates of china and porcelain. According to experts, only one thousand of these crates were salvaged. The modern-day value of this china makes the *Sindia* a true treasure wreck. Back in 1901, the cargo—which is still largely disputed and unresolved—was supposedly worth $1 million, back then a huge amount and today worth twenty times more. The only problem is that the wreck is now completely buried beneath the beach off Seventeenth Street in Ocean City. The *Sindia* is not a scuba diving wreck, since it lies under as much as thirty feet of sand, and like any shipwreck in the three-mile State of New Jersey Territorial Boundary, you have to cut a deal to salvage her. Good luck with that.

It is, however, of historic interest, since she was carrying a treasure in Far Eastern porcelain and art works—even a gold Buddha—much of which treasures are still thought to be buried inside her steel hull, waiting to be dug out. One possible rumor put forth by a local historian is that the wreck of the *Sindia* was the result of an intentional plot to run the ship aground and that John D. Rockefeller, whose Anglo-American Oil Co. bought the ship in 1900, was probably part of the conspiracy. It is said that Rockefeller was smuggling silver out of China during the chaos of that country's Boxer

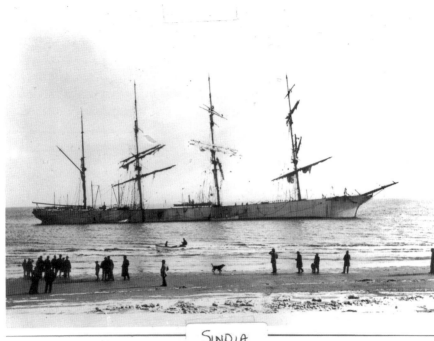

SINDIA

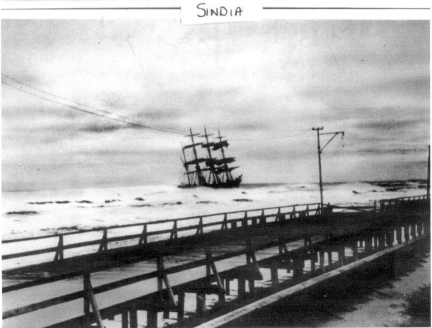

The *Sindia* sank off the beach in Ocean City. Few images remain, but these were featured postcards of the event drawing tourists to see the wrecked ship. *Peter Hess*.

Rebellion. Certainly all of this conjecture is plausible, considering the value of the supposed cargo. Make no mistake—several items of porcelain and china on display at the Ocean City Historical Museum are from the *Sindia*, so something good is buried there.

Silver Ingot Barge

One of the stories my father used to tell me about was the lost silver in the Arthur Kill River that separated my hometown of Carteret from Staten Island. He worked the smelting plants there during his lifetime. In September 1903, a barge load of silver ingots was being transported to Perth Amboy. The barge contained 7,678 one-hundred-pound ingots, which were being delivered to the American Smelting and Refining Company. The barge rolled over and dumped its valuable cargo into the murky waters of Arthur Kill. For the longest time, the river was one of the area's most polluted. Over thirty years ago, it was considered little more than an open sewer—dirtier at times than the sewage flowing to treatment plants. Back then, the eleven-mile waterway separating Staten Island from New Jersey was taking in 6 million gallons a day of raw sewage. This story always fascinated me, especially when I worked at the smelting company during college. Right there under that river was a fortune in silver, so close—but no way was I going to jump into that toxic mess.

The Baxter Wrecking Company hired to recover that loss found the pile of silver scattered across the silty bottom. In five days of salvage, 2,938 ingots were recovered. Another ten days of salvage turned up an additional 3,000 ingots. In total, about 80 percent of the barge's cargo was recovered. According to the *Treasure Diver's Guide*, "There should be about 1,400 100-pound ingots still lost under the mud." Well, the river has cleaned up a lot since my summer days there in 1974–75. As a matter of fact, environmentally, the river is making a great comeback. And think about this: 1,400 one-hundred-pound ingots are worth over $300,000 dollars at current silver prices today. Treasure!

ROBERT J. WALKER

CIVIL WAR CONNECTIONS

The *Robert J. Walker* became a ship lost in time. For 153 years, her final resting place was unknown. Her sinking, by collision with the coal schooner the *Fanny* on June 21, 1860, was a tragedy of the time, not only for the loss of twenty-one men and the vessel but also because her memory would quietly fade into history.

There was never much serious inquiry into the cause of the collision or even who was responsible. The *Walker* was a government vessel, operated by the U.S. Coast Survey, and her wreck should have been more closely looked into. But events were transpiring to push the memory of the *Walker* into the background, where she eventually was forgotten. In late 1859, John Brown tried to destroy Harpers Ferry in Virginia and the sentiment of the nation about slavery inflamed many. In November 1860, Abraham Lincoln was elected the sixteenth president, and by December, South Carolina elected to secede from the Union, with six other Southern states soon to follow. At Fort Sumter in Charleston Harbor, South Carolina, in April 1861, the Civil War began.

As the war took hold of the nation, the *Walker*'s location and possible salvage was pushed aside. Yet the USCS *Robert J. Walker* played a vital role for the war and our nation's waterways. As a coastal survey vessel, the *Walker* and her crew members performed over half a million soundings from the Gulf of Mexico and, to a smaller extent, up the East Coast of the United States. These soundings required men to laboriously lower and raise a lead weight and knotted line marked in lengths of feet or fathoms into the

This 1852 oil painting of the *Robert J. Walker* is by W.A.K. Martin and is located at the Mariners Museum. *NOAA.*

water to determine the soundings or the actual depth of the harbors, the approaches to the coastlines and the navigable parts of inlets. This would be critical to the young nation's maritime commerce. As it turns out, the *Walker*'s connections to the Civil War was in her soundings, used to provide the Union naval vessels with useful information about where the best places would be to blockade deep-water access to the Southern ports and force Confederate ships to approach shallow water to run a blockade if they dared. So while the sinking of the *Walker* was a forgotten event, her crew's contributions would still have a significant impact on the war.

THE VESSEL

The 132-foot and 305-ton USCS *Robert J. Walker* was one of the first iron-hulled side-wheel or paddlewheel steamers built for the Revenue Service. The Revenue Service would eventually become the United States Coast Guard in 1915 through a law signed by President Woodrow Wilson, which is another *Walker* connection to New Jersey. (Wilson was president of Princeton University for eight years just prior to becoming the thirty-fourth governor

of New Jersey.) Even though it was constructed as a revenue steamer, it was turned over to the U.S. Coast Survey instead. The Coast Survey itself would become folded into the National Oceanic and Atmospheric Administration (NOAA), which was created in 1970.

According to NOAA history, the Coast Survey was often referred to as the nation's oldest scientific agency. The "Survey of the Coast" was established on February 10, 1807, by President Thomas Jefferson. The increasing importance of waterborne commerce to the new nation prompted Jefferson to sign legislation to "cause a survey to be taken of coasts of the United States." The Coast Survey conducted its early activities under the U.S. Department of Treasury, where it shared vessels with the United States Revenue Cutter Service.

The *Walker* was deemed too slow to be used as a revenue cutter, which was charged with customs functions such as stopping smuggling and generally protecting the commerce coming into and out of the nation's ports. These vessels needed to be fast and were usually armed. The *Walker* was not fast. At best, she could manage seven knots at full steam. According Benjamin Isherwood, chief engineer for the United States Navy, the *Walker* had undersized paddlewheels for a ship of her size, which caused her slow speed through the water. In fact, it required 840 pounds of anthracite coal per hour to manage that speed of seven knots (eight miles per hour). Imagine how quickly we'd get rid of our cars if we needed to carry eight hundred gallons of gas to travel eight miles per hour. It was an easy decision by the treasury to pass on the brief experiment of using these large, inefficient, paddle-wheeled steamships and the enormous expense to maintain them.

During this time period, steamships were used extensively on inland waters, but their use on the open oceans was sparse, as operators preferred the sleek and fast clipper ships. It wouldn't be until the 1880s that steamship technology became more accepted, trustworthy and faster than sail. Like most of the steamships built during this period, the *Walker* was built in Pittsburg, Pennsylvania.

THE COLLISION

On June 21, 1860, the Coast Survey steamer *Walker*, with a crew of seventy-two (and with the wife of executive officer Joseph Seawell on board), was lost at sea as the result of a collision. Twenty-one men died in this accident, making it the worst single disaster to strike the Coast Survey.

It was literally a dark and stormy night as the *Walker* steamed from Norfolk, Virginia, toward New York in a blowing gale and rough seas. Its executive officer, Joseph Seawell, spotted the approaching schooner *Fanny*, which was carrying 240 tons of coal to Boston. Though both ships were clearly lighted, they somehow collided at 2:15 a.m., with the *Fanny*'s bow anchor striking the *Walker*'s bow, opening the hull plates and destroying two lifeboats. Seawell sent men below to determine the damage but quickly realized it was to no avail. He then instructed that the mainmast be cut down and any floatable parts of the ship tossed overboard to be used as buoys. Meanwhile, the men below were desperately trying to save themselves and their ship by keeping the steam up to head toward shore and stuffing mattresses, blankets and whatever they could find to plug the gash on her port side, just past the bow; others used axes to chop down the mainmast for use as a flotation device. But too much water was gushing in, and their efforts would fail. It is likely that these men were the victims in the sinking. Orders to abandon ship were given; the *Walker* was sinking quickly, despite a great effort by a few sailors.

The collision took place about ten miles off the coast of Absecon Island. Executive Officer Seawell noted the heroism of the crew members as they maintained their posts, trying to save the *Walker* as she was reeling from the collision. The ship was settling by her bow quickly.

On June 23, 1860, the *New York Times* wrote about the accident:

> *The following list of the missing crew was supplied to the paper by Mr. Charles Gifford, quartermaster on board the* Walker, *to whom we are also indebted for the particulars of the collision: Marcus (or Marquis) Buoneventa, wardroom steward; Michael M. Lee, ship's cook, (colored); James Patterson, wardroom cook (colored); Henry Reed, second mate; Timothy O'Connor, second [sic] gunner; John Driscol, seaman; Michael Olman, seaman; George W. Johnson, son of Mr. Johnson, the actor; Charles Miller, ordinary seaman; Robert Wilson, seaman; John M. Brown, captain of after guard; Jeremiah Coffee, cooper; Cornelius Crow, landsman; John Farren, fireman; James Farren, fireman; Samuel Sizer, fireman; George Price, fireman; Joseph Bache, fireman* [Note: reported in the *Herald* as "Bate"]; *Daniel Smith, fireman; Peter Conway, fireman; The total number of men lost in the sinking was 21.*

Officer J.J. Seawell, his wife and Captain John McMullen survived, along with fifty-one others. One of the survivors would die from injuries and exposure. The survivors were plucked from lifeboats by a passing schooner,

the *R.G. Porter*, commanded by Captain S.S. Hudson, who kept his vessel within the area that the *Walker* sank in for several hours searching for additional sailors. Ultimately deciding there were no more, he sailed with the surviving passengers of the *Walker* into Cape May.

It was surmised at the time that, having collided with the *Walker* in the rough seas, the *Fanny*, herself damaged, assumed the *Walker* was not as mortally wounded by the collision as she was and left the scene to make port as quickly as possible. Hours after the event, as the rescue vessel *R.G. Porter* put into Cape May Harbor with survivors aboard, everyone noticed a schooner was already in port with damage evident to her foresail (sail and mast near the bow), head spars (used to support a sail or mast) and cutwater (the forward curved part of the ship's bow). This was very likely the schooner *Fanny*.

The *Walker*'s final location was in dispute at the time of her sinking. The captain and the executive officer each had determined the depth of water and ship's speed differently, as each had different perspectives during the confusion of the collision and sinking. The captain had placed the *Walker* only five miles offshore, while the executive officer put the *Walker* closer to ten or twelve miles away. This conflicting information contributed to the mystery of where she sank, and for 153 years, the *Robert J. Walker*'s final resting place remained unknown.

The April 2014 *Philadelphia Inquirer* story about the expedition to map the *Walker* quotes James Delgado, director of the Office of Maritime Heritage at NOAA and an advisor of our expedition, who explained, "These were real people like you and me who got caught up in something bigger than themselves. History, to me, is more than big names and big events. It's about the guys on the *Walker*, and the wreck is their grave site." *Inquirer* writer Edward Colimore researched and contacted Lisa Sulley, of Cranford, Union County, whose great-great-grandfather Timothy O'Connor was lost in the *Walker* disaster. Sulley said, "It's almost bone-chilling to know I had a relative" on the *Walker*. "I was in my 30s when I first heard about it, and it means something to me today, even though it's so many generations away."

In 2013, the NOAA survey vessel *Thomas Jefferson* was working up the New Jersey coast using her side-scan sonar equipment to search for any debris from Hurricane Sandy that might prove to be a potential maritime hazard. As the ship was passing off the coast of Atlantic City, NOAA historian Albert Skip Theberge, who was anxious to actually find the *Walker*'s position and had done most of the research into her history along with archaeological graduate student and local New Jersey diver Joyce Steinmetz and NOAA sonar expert Vitad Pradith agreed to search the area for the wreck. They

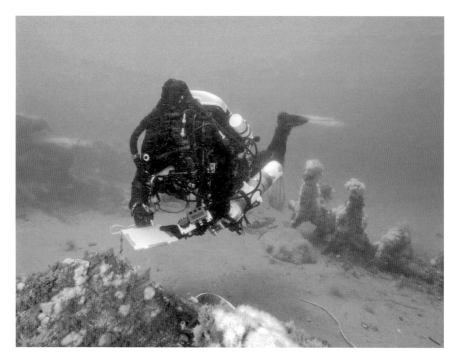

A diver mapping near the port side of the *Walker*'s bow, the likely place of the collision that doomed the men and ship. *©Herb Segars, gotosnapshot.com.*

used both of the last reported positions recorded by the *Walker's* two officers as well as getting some local knowledge to aid in their search.

In the early 1960s, the local charter boat skipper Eddie Boyle dived a previously unknown wreck only he knew about. He saw during his dive it was a paddlewheel steamship and recovered a small square brass porthole. Archaeological graduate student Steinmetz noticed on the only known image of the *Walker,* an 1852 oil painting by W.A.K. Martin, that the steamship had square portholes. It would provide the first clue to the eventual identification of the site as that of the *Robert J. Walker.* Captain Boyle had named this private spot the twenty-five-dollar wreck because that was the price for which he had sold the wreck's location to other local fishing chapter boats. Unknown wrecks like this are prized spots for charter boat skippers, who are able to take their customers to spots few others know, thereby increasing the chance of finding fish there.

Using the sonar equipment aboard the *Thomas Jefferson*, technicians provided images that verified the overall dimensions of the wreck at 131.5 feet—pretty close to the *Walker's* 132-foot original construction. Further

underwater examination concluded that the paddlewheel and engines were a match for the *Walker*. NOAA had finally identified the long-forgotten ship of its predecessor agency, the Coast Survey, and the greatest loss of life in the combined history of both organizations. In deference to the service of the vessel and crew, and because of the historical significance of the vessel and the survival of portions of the wreck, NOAA nominated and successfully placed the wreck site on the National Register of Historic Places on April 2, 2014. The wreck is more than a historic site, said James Delgado, director of NOAA's Office of Maritime Heritage (OMH). It's the final resting place of twenty-one men, lost when the ship went down on June 21, 1860.

More than a century and a half later, in a murky, emerald green world eighty-five feet down, NOAA archaeologists on dives to the wreck in 2013 found some evidence of gray wool blankets buried and partially decomposed near the spot where the collision no doubt took place—grim evidence of the wrecking and the men that might lie close by.

THE WRECK SITE

The wreck site of the *Robert J. Walker* lies approximately ten nautical miles south-southeast of Absecon Inlet, Atlantic City, New Jersey. Coincidentally, the Absecon Lighthouse that represented potential salvation for the crew of the *Walker* was itself built because of a previous shipwreck off Atlantic City, that of the *Powhattan*, a vessel carrying 311 German immigrants that sank in 1854. For days, bodies washed up on the shoreline from that disaster. At the urging of Dr. Pitney, a lighthouse was erected in 1854 and turned on one year later. The lighthouse, in the inlet section of the city, was originally at the edge of the ocean, but it now stands over half a mile from the beach.

The wreck of *Robert J. Walker* lay with her bow upturned from the collision with the seafloor at the time of her sinking and facing the north-northwest and on a sandy, sometimes muddy sea bottom in a slight depression. Nothing left of the wreck resembles the painting of the *Walker*, but many parts of the wreck are readily identifiable, if you know something about ship construction or are an experienced New Jersey wreck diver.

In early 2014, James Delgado, director of NOAA's OMH, asked Dan Lieb of New Jersey Historical Divers and myself to lead an expedition to map the *Walker* site for the government. The *Robert J. Walker* Shipwreck Mapping Project is part of a new initiative and outreach from the

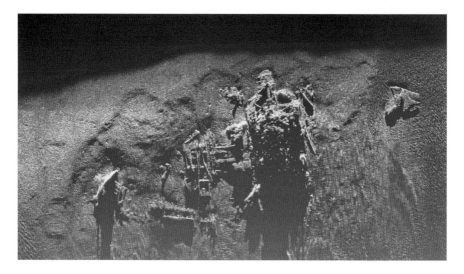

A sonar image of the *Robert J. Walker*. The image shows the bow, the engines and paddlewheels and a small piece of what is left of the stern. *Stockton University's Marine & Environmental Science Field Station and Vince Capone of Black Laser Learning.*

government's National Oceanic and Atmospheric Administration, Office of National Marine Sanctuaries (ONMS). This collaboration among essentially non-governmental entities is one of the first projects of its kind in the Northeast.

Since the primary goal of this expedition was to collect enough data to create a site plan and a perspective illustration of the wreck site, divers mapped the bow and stern features, the area forward of the boilers and exposed port side, and collected measurements on all four anchors found at the site. The boilers and engine were also mapped, and in enough detail to identify the boilers as those depicted in a survey of the *Walker*'s refit in 1852, and the patent engines she was outfitted with when she was built in 1847. Expedition videographers and photographers recorded divers as well as recording all aspects of the shipwreck site to provide "post-dive" analysis for the mapping. Over four days of diving, a collective total of forty-eight hours was spent on the bottom.

To facilitate the successful completion of this joint project, it was important to enlist several key partners besides the members of New Jersey Historical Divers Association. Along with Black Laser Learning's Vince Capone, we approached Stockton University's Dean of Natural Science and Mathematics for help from their Marine Sciences Field Station. Both Vince and I had relationships with Stockton and were well aware of the equipment

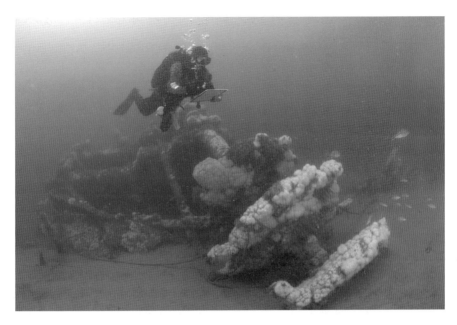

A diver mapping the starboard paddlewheel of the *Robert J. Walker*. *NOAA and Joe Hoyt*.

Stockton University's sonar mapping team. *Stockton University's Marine & Environmental Science Field Station and Vince Capone of Black Laser Learning.*

and capability that Stockton possessed and how important it would be for mapping the wreck site remotely prior to physical dive operations. Stockton University's marine science field station has state-of-the-art side-scan sonar systems and a remotely operated vehicle (ROV) system to underwater remotely map and record video of the wreck. Professor of biology Dr. Peter Straub, along with field station director Steve Evert and dean of Natural Science and Mathematics Dennis Weiss, readily and graciously agreed this would be a great opportunity.

Perhaps the most significant fact we discovered for ourselves during this expedition was that the site had been disrupted by mechanical means. Aside from the usual state of collapse we expected to find at a wreck site that is 155 years old, it had obviously been impacted by mechanized commercial fishing practices. Mapping expedition divers found sections of wreckage torn from others with fishing nets still drawn tight throughout them. They also found pot fishing line entangled throughout some areas. Other wreck sites nearby also showed the same signs of impact by commercial fishing gear, including dredging hardware still lodged in place. While the bow and stern of the *Walker* seem to have given way to the ravages of the ocean and time, the port engine has been torn so completely apart as to be drawn far out of place, and the entire port paddlewheel was broken off, rotated 180

The *Walker* dive team posing aboard the dive boat *Venture II* with the Explorers Club Flag #132. © *Herb Segars, gotosnapshot.com.*

The final wreck site drawing by co-expedition leader Dan Lieb. All of the sonar, diving and mapping culminates with this image, now part of the NOAA government report on the wreck. *Dan Lieb, of the New Jersey Historical Divers Association.*

degrees and toppled upside down. This is in stark contrast to the fact that the starboard engine and paddlewheel seems relatively intact, so much so that its basic operation and movements may be determined from a cursory glance. Clearly, the commercial fishing industry has had a dramatic effect on this historically significant site. While this discovery could have an effect on legislating how commercial fishing is conducted in the ocean, it is more likely that some sort of "area of demarcation" will be placed on nautical charts noting the historic site and warning fishermen of impending entanglements. It makes little sense for them to risk such a financial loss of hundreds if not thousands of dollars in fishing gear.

Two other expedition goals were resolved with a post-construction nautical survey of the *Walker* prior to her sinking that included revised plans of her newly installed boilers. Those plans match the boilers we see at the wreck site today. The *Walker* was built with an engine design that was patented and unique among those vessels that wrecked off New Jersey. Observations and recordings show this is exactly the design of the engines at the wreck site. While NOAA's claim that the site is the *Robert J. Walker* was felt to be speculative at best by some, this expedition supports this claim, proving without a doubt the identity of the wreckage as the *Robert J. Walker*.

The success of this mapping operation should indicate to legislators and policymakers that there is "common ground" between the archaeological community and the other communities that utilize shipwreck sites. If future expeditions are planned, the site plan this expedition produced may be used to guide archaeological excavations. There is a permanent exhibit totally funded by NOAA about the *Robert J. Walker* at the New Jersey Museum of Maritime History located in Beach Haven on Long Beach Island, New Jersey.

Chapter 7

SUBMARINE

THE JERSEY SHORE AND THE WORLD WARS

When you think about history and the world wars, you wouldn't automatically associate the coast of New Jersey as a naval battlefield. However, the fact is that New Jersey had a role in almost every war fought on this side of the Atlantic from the French-Indian to the Revolutionary, Spanish-American, Civil War and now both world wars. It was during periods of both world wars that the coastline of New Jersey became the playing board for the game called war. German submarines, called U-boats (*unterseeboots*—undersea boats), operated up and down the East Coast of the United States. Tactically and economically, it makes a lot of sense. Stop merchant shipping from getting to Europe and cut off resupply. Keep these submarines on patrol all along the coast and sink ships. The submarines were the most advanced of their time, better than what any other nation had. And they did sink ships—lots of them. Their purpose was to create chaos and a distraction to keep us focused here as opposed to what they were doing over there. It didn't work out all that well for them at the end, but they sure tried pretty hard.

BLACK SUNDAY: WORLD WAR I

The United States tried to remain neutral, but events overseas kept pushing us toward entering the war. Several U.S. ships were damaged or sunk by mines, and then a merchant ship, the *William P. Frye*, was sunk. One

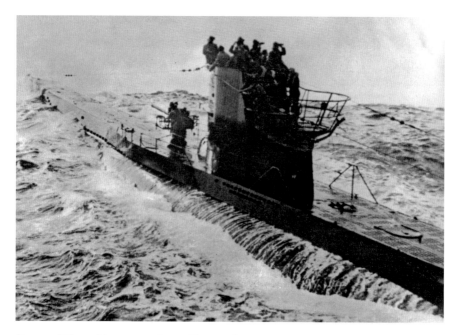

German U-boats like the one pictured here sank many vessels off the New Jersey coastline during two world wars. *Mariners Museum.*

of the events that helped to force our hand to enter the war came in 1915 after Germany announced that it would operate unrestricted warfare in the Atlantic Ocean and sink any and all ships, including those carrying civilians, which were sighted in war zones. The German Admiralty had announced earlier in the year it would have unrestricted submarine warfare in the waters surrounding England and had, in fact, sunk or damaged several United States ships. The Germans went so far as to place a notice in the newspaper to this effect, right next to the sailing itinerary of the *Lusitania*, which the Germans suspected of carrying more than just passengers. The captain of the liner refused to take precautions suggested by the British on the voyage, and as a result, the *U-20* torpedoed without warning the British passenger liner *Lusitania* on May 7, 1915. The ship sank in eighteen minutes, and 1,198 passengers drowned, including 128 Americans.

New Jersey's connection with World War I and German U-boats began on June 2, 1917. The *U-151* was the first German U-boat to operate in U.S. territory in World War I. It is credited with sinking six ships all on the same day—Sunday, June 2, 1918—in what would be referred to as the Black Sunday wrecks. At 7:50 a.m., the Bath, Maine–built schooner *Isabel B. Wiley* would be

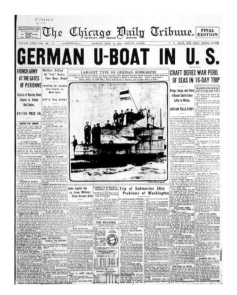

Left: These 1916 headlines from the *Chicago Daily Tribune* announced that German U-boats were operating off the United States coastline. *Mariners Museum.*

Right: The *Boston Daily Globe* reported the sinkings of what became the infamous Black Sunday wrecks, victims of the *U-151*. *Mariners Museum.*

the first kill by the *U-151* when she was bombed and sunk in 210 feet of water; no casualties were reported. Little more than an hour later, at 9:12 a.m., the freighter *Winneconne* was also bombed and became the second victim in 220 feet of water. The U-boat was working an offshore box-like pattern, moving forty miles or so on the north–south sides and about twenty miles on an east–west line. Moving twenty miles to the north-northwest, the submarine bombed and sunk the schooner *Jacob M. Haskell* at noon in 200 feet of water, again with no casualties. The *U-151* turned south to sink the schooner *Edward H. Cole* in 185 feet of water at 4:00 p.m. The submarine would turn to the east to sink its fifth ship, the freighter *Texel*, at 5:20 p.m., and finally, in the early evening, at 7:20 p.m., the *U-151* closed the attack box by turning north to shell the passenger liner *Carolina* in the deepest water, at 250 feet.

According to reports, at around 6:00 p.m. the *U-151* fired one shell at the *Carolina* and then ordered her captain to surrender and abandon ship, which the captain of the *Carolina* so ordered and put everyone into lifeboats. At approximately 7:30 p.m., the *U-151* fired three shells at the SS *Carolina*, sinking her. Most of the ship's boats stayed together and survived a squall during the night. The schooner *Eva B Douglas* picked them up at

11:00 a.m. the following day, June 3. One lifeboat made it to the coast at Atlantic City, and another was picked by the British steamship *Appleby*. At 4:00 p.m., the Danish steamship *Bryssel* found the swamped motor dory from the *Carolina*, with eight male passengers and five of the *Carolina*'s crew; all had drowned. It was the first loss of life caused by U-boat activity on the U.S. Atlantic seaboard.

It was a busy and successful day for the captain of the *U-151*. Dr. Frederick Körner, the boarding officer on the *U-151*, was quoted on the sinking of the SS *Carolina*: "The lifeboats were crowded, and a great wailing of women's voices rose. There was praying and pleading. The negroes thought we were going to use them for target practice." One can only imagine what went though the minds of those forced into lifeboats under the guns of the ship that fired upon them.

The total casualties for all six vessels were only 13, amazing considering that 448 persons were imperiled and over 21,500 tons of shipping was damaged or destroyed. The 13 casualties that did occur were the result of a capsized lifeboat from the SS *Carolina*, not hostile action by the U-boat. The captain of the *U-151* could afford to act in such a chivalrous manner for several reasons. *U-151* was the first U-boat ever to operate in U.S. waters during World War I. Wireless radio technology was still at a primitive state, and anti-submarine patrol aircraft were unheard of. This gave the submarine the advantage of surprise and the luxury of being able to operate on the surface, allowing time for each victim's crew to escape before finishing the attack.

The Black Sunday wrecks were not the only know ships sunk directly off the New Jersey coast during World War I. Mines placed by the *U-117* the following year off Atlantic City sank two more vessels. The *U-151* sank a number of other vessels off the coast of Virginia before returning safely to Germany. After World War I, the captured *U-151* was brought to America and finally sunk in bomb tests. The *U-151* would total twenty-three ships sunk, plus four by her mines, totaling sixty-one thousand tons. She traveled over ten thousand miles in ninety-four days. The Germans, emboldened by this success, would send more submarines this way—only to find that the United States Navy was now prepared to stop them.

The wreck of the SS *Carolina* was dived in the mid-1990s, and many artifacts were recovered by diver John Chatterton in 1995 and on later trips. Chatterton lodged a salvage claim for warrant of arrest in the United States District Court–District of New Jersey Camden Division, arresting the ship and naming himself custodian of the wreck. The salvage case was heard by

One of the Black Sunday wrecks was the *Edward H Cole*. *Mariners Museum.*

Federal District Court judge Joseph Rodriguez, whose father, ironically, had been a passenger on the *Carolina* and landed at Atlantic City in one of the lifeboats. Chatterton and his expedition recovered the letters off the stern of the *Carolina* as well as her purser's safe, complete with gold coins and jewelry.

The SS *Carolina* passenger liner was one of the ships sunk during Black Sunday. *Mariners Museum.*

WORLD WAR II: OPERATION DRUMBEAT (OPERATION *PAUKENSCHLAG*)

After Japan attacked Pearl Harbor and Germany entered the war against the United States, Admiral Karl Dönitz, the commander of the German U-boat fleet, saw an opportunity for a quick and decisive strike against United States shipping and quickly drew up plans for a devastatingly swift blow on the U.S. eastern seaboard. Dönitz wanted to strike with twelve Type IX boats, which were the only boats capable of cruising that far. But he was forced to reduce that number to six boats due to other engagements of Hitler's preferences of the Gibraltar area. One of the six boats marked for this operation was in need of urgent repairs and could not make it in time. Thus only five boats sailed in what was known as Operation Drumbeat.

The Operation Drumbeater submarines disembarked; the *U-125* (Captain Folkers) was the first to sail on December 18, 1941, followed by *U-123* (Captain

Hardegen) on December 23 and *U-66* (Captain Zapp) on the following day. Finally, the last two of the Paukenschlag boats, *U-130* (Captain Kals) and *U-109* (Captain Bleichrodt), sailed together on December 27. It would take them just over two weeks to reach U.S. waters. They were under strict orders not to attack anything on the outbound cruise unless an especially attractive target was located (this meant a big warship like a cruiser, carrier or a battleship, but as Dönitz had said, "We never let a 10,000 tonner pass us by").

All the boats were to be in position on January 13 and begin their attacks at the same time on that date. However, *U-123* sank the first ship, the SS *Cyclops* on January 11, and Kals in *U-130* sank two ships the next two days. After that, they felled more than one a day as far south as Cape Hatteras.

The Operation Drumbeat boats ended operations off the coast of the United States on February 6 and headed home. They had sunk twenty-five ships for a total of 156,939 tons. Captain Hardegen sank nine ships for a total of 53,173 tons.

American operations continued. This may surprise many of you, but Operation Drumbeat really was just the initial wave of five large U-boats. The Paukenschlag was meant to be a fast and surprising attack on the eastern seaboard of the United States, and it succeeded as such. Then there were several other "waves" of U-boats that went into American waters, but those don't really count as Drumbeaters. When all five of the Type IX submarines returned to France, Dönitz actually criticized *U-125*'s commanding officer Ulrich Folkers for his lack of aggressiveness, having destroyed only one Allied ship. Dönitz later wrote that on this first expedition to the American coast, each commander "had such an abundance of opportunities for attack that he could not by any means utilize them all: there were times when there were up to ten ships in sight, sailing with all lights burning on peacetime courses."

The success led to second and third waves of German submarines being sent to the U.S. coast; around this time, the nickname "Second Happy Time" began to surface, with the initial success known as the First Happy Time. In addition to the long-range Type IX submarines, shorter-range submarines were being dispatched to North America as well, with all available space used for extra food, water and fuel to extend the submarines' range. During the Second Happy Time, which lasted more than seven months, the Germans sank 609 ships totaling 3.1 million tons at the cost of only twenty-two submarines. This number would represent about 25 percent of all Allied shipping sunk by German submarines during the entire war. In total, German U-boats would sink over 3,000 ships. There are approximately 22

known vessels that were torpedoed by U-boats off the Jersey coast in 1942, though none were lost to submarines in 1943, and only 3 were sunk in 1944–45. Several were lost by collision or other means, but by the end of 1942, the United States had access to better locating equipment to find U-boats and better intelligence, not to mention an aggressive navy on the constant lookout for them.

The final U-boat found off New Jersey was actually discovered in 1991 by a group of divers who were looking at "hangs," or unidentified spots in the ocean where commercial fishermen got the fishing gear hung up on some underwater obstacle. A "hang" can be a virgin shipwreck, never seen or dived before, or it can be timbers, rocks or junk—totally not worth the dive. This "hang" was sixty-five miles offshore in 240 feet of water. Everyone onboard knew it could wind up being either a long trip for nothing or something special. Either way, it was very dangerous diving and only suitable for those with experience and equipment to match the depths. Diver John Chatterton was first in the water. As he made his way to the bottom, he knew it was a wreck, but it looked unlike what he expected. It turned out to be a submarine.

After several diver artifacts were found that identified it as a German U-boat, it was nicknamed the "U-Who" by Chatterton. As a result of some serious research in the United States and in Germany during the mid-1990s, John Chatterton, John Yurga and Richie Kohler found out it was the *U-869*. The Germans had thought this sub to be sunk in Gibraltar in the Mediterranean. What was it doing sixty-five miles off the New Jersey coast?

The wreck sits upright in very deep water, with a huge hole on the port side and the conning tower knocked off and lying in the sand. The commonly accepted story is that the sub was destroyed by one of its own torpedoes, which circled back on itself and homed in on the sound of the wrong target. There is new information that suggests that the U.S. Coast Guard–manned *Howard D. Crow*, a destroyer escort, and USS *Koiner* chased down a submerged contact on February 10, 1945, using depth charges. It is suggested that the condition of the submarine, which shows two large holes, seventy-five feet apart, probably is not possible from one torpedo, but it does fit a barrage of depth charges. The two destroyers were ordered to break off the attack and to resume their anti-sub patrol on a merchant ship convoy heading to Europe, and their attack was listed as non-sub contact. Did these two ships sink the *U-869* or was it an errant torpedo? Their attack area was only five miles from the actual site of the *U-869*. Was this coincidence or did they bomb a wreck already in the area, as the report stated? It's an interesting story that was turned into a few books and television specials.

These wrecks act like ocean reefs attracting and supporting sea life. *Olga Torry, www. liquidimagesuw.com.*

The sinking of the *R.P. Resor* would provide firsthand experience to New Jersey beach-goers about their involvement in the war. The oil-filled tanker burned for a few days, lighting up the skies. Watching ships like this one explode and sink made the war all too real for the people here, who had thought they were safe. The Federal Ship Building Co. in Kearney, New Jersey, built the *R.P. Resor* in 1935. She was launched on Saturday, November 13, 1935. She was a 445-foot-long, 66-foot-wide tanker and was owned by Standard Oil Company (now Exxon Corp.) The *R.P. Resor* was the first vessel built in the United States on the Isherwood Arcform hull design, which was a new design for making a ship's hull stronger, able to carry more crude oil while allowing the ship to maintain an efficient cruising speed. It would be an economic advantage for tanker companies. The *Resor* was also the first new ship to be fitted with a Contra Guide propeller and rudder, which is warped instead of being symmetrically streamlined. This system claims to add more speed and better maneuverability at the same power. She displaced 7,451 tons and was under the command of Captain Frederick Marcus.

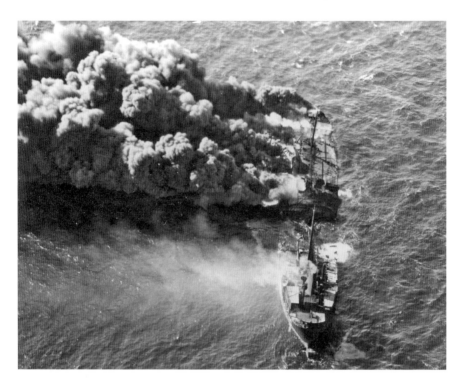

The tanker *R.P. Resor* burning after being struck by a torpedo. She was carrying fuel oil and gasoline. *Mariners Museum.*

On February 27, 1942, the *R.P. Resor* was traveling from Houston, Texas, to Fall River, Massachusetts, with 78,729 full barrels of crude oil in her holds. Seaman Forsdale was on lookout duty. He spotted a ship off the port bow with its running lights on. Forsdale thought it was a fishing smack (a type of fishing boat that was fore-aft rigged but contained some type of well to store fish. The Fishing Smack was prominent in the 1900s but eventually disappeared by the late 1940s) and reported his sighting to the bridge. This, however, was just a ruse allowing the German submarine *U-578* (*Rehwinkel*) to maneuver to within two hundred yards before firing a torpedo that exploded amidships. The U-boat then fired another torpedo, which ruptured the *Resor's* oil tanks, setting fire to her and to the oil-covered waters around her.

As flames enveloped the tanker, men leaped into the water or tried to launch lifeboats. Out of a crew of forty-one plus nine naval-armed guards, only two survived, one being a crew member and the other a navy guard. The two who survived her initial explosion and fire were almost lost while

A diver exploring the remains of the many shipwrecks caused by U-boats during two world wars off the New Jersey coast. *Larry Cohen. www.liquidimagesuw.com.*

This image is of the stern gun on the *R.P. Resor*, now pointing down toward the sand and covered in marine growth. *Courtesy of Peter Brink.*

being rescued. Crude oil from the sinking vessel had covered both men, making them heavy and extremely slippery. Chief boatswain's mate John Daise, commander of the Coast Guard picket that rescued both survivors, said that the men were coated with thick, congealed oil and weighed over six hundred pounds. The Coast Guard cut off the men's clothes to lighten them. Daise went on to say that even the survivor's mouths were filled with blobs of oil. Fortunately, the rescuers were diligent and finally did succeed in lifting the half-drowned, exhausted men to safety.

The *Resor* stayed afloat for two more days, burning the whole time. Crowds thronged to the beaches at Asbury Park to watch flames billow up on the horizon. The USS *Sagamore* made a futile attempt to tow her ashore for salvage, but the sinking ship's stern bottomed out in 130 feet of water. Soon after, the *Resor* rolled over and slipped beneath the waves. The *Resor* was the twenty-fourth ship and fifteenth tanker sunk or damaged in U.S. coastal waters since the U-boat campaign had begun.

The *Resor* is now one of New Jersey wreck divers' preeminent offshore dive sites. Most of her remains are scattered and low-lying, evidence of the force of the explosions and fires that sunk her. The wreck is known for holding big lobsters. The stern, which is relatively intact, still rests in 130 feet of water. The stern deck gun, which is still in place, points downward to the clean sandy bottom. Following the barrel of that deck gun to the sand and wreckage located there often produces one of those huge lobsters.

Chapter 8

COLLISION AT SEA

SS MOHAWK

Storms, wars and unforgiving coastlines have accounted for the shipwrecks discussed thus far in this book, but with the SS *Mohawk*, *Morro Castle* and *General Slocum*, we look at how fire, human error and poor seamanship caused shipwrecks and how these wrecks altered United States Coast Guard regulations regarding crew training, shipboard inspections and safety of all equipment necessary for operation of a passenger ship. There have been many maritime accidents along the coasts. The iron-hulled paddlewheel steamship *Robert J. Walker* sank because of a collision with a wooden sailing ship in 1860. The "Pride of the Italian Line," passenger liner *Andrea Doria* sank after it collided with the freighter *Stockholm in 1956*; the Israeli passenger liner *Shalom* collided with tanker *Stolt*, cutting the wreck in half and causing the tanker to sink sixteen miles off Manasquan Inlet on Thanksgiving in 1964. They all share two common things: collision at sea was the cause of sinking, and in every case, it was avoidable. The *Walker, Doria* and *Stolt* clearly saw another ship coming either visually or on radar, and then inexplicably, they collided and each of them sank.

This brings me to the story of the SS *Mohawk*. No surprise—she also was involved in a collision at sea. At this time in history, economics influenced the modifications of steamships to the point they were likely made less safe in order to carry more valuable cargo in part due to the Great Depression. These modifications involved opening up her watertight bulkheads for easier cargo handling. Because of this, she would be in danger if she experienced

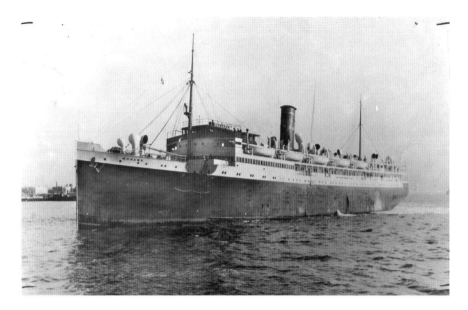

SS *Mohawk. Mariners Museum.*

any type of problem or accident. The owners were betting their futures on the risk versus the financial benefits. They would lose.

A year earlier, the *Morro Castle* was lost by fire, and the Clyde-Mallory and Ward Lines had experienced several wrecks over the past decade. Losing the SS *Mohawk* under these conditions was the last nail for the shipping lines. They couldn't overcome the publicity or the investigation's outcome, and lines folded. The blame for the collision is variously given as mechanical malfunction or human error, but the *Mohawk* veered directly across the path of the other vessel and was entirely at fault. None of the bridge officers survived the accident. Captain Joseph Wood chose to go down with his ship; in the end, the responsibility for a vessel rests solely with its captain, and the press and the courts would have crucified him had he not chosen this fate. Transcripts of the investigation questioned whatever officers were left alive from the *Mohawk* as well as those aboard the *Talisman*.

The *Mohawk* left New York on the afternoon of January 24, 1935, after what was being talked about as the worst winter storm deposited seventeen inches of snow in the area. The ship left port covered in snow and ice. About 9:00 p.m., several miles south of Sea Girt Light and about six miles offshore, the steering gear went awry, and the crew switched to a manual steering system instead. Shortly afterward, confusion between orders from the bridge

and their execution in the steering engine room caused the *Mohawk* to execute a hard turn to port, at full speed, directly into the path of the Norwegian freighter *Talisman*. Although both ships tried to avoid the collision, it was too late. *Talisman* struck the *Mohawk*. The fatal blow was on the port side, and the *Mohawk* began to take on water quickly. Modifications that were made to the ship would now come into play in her demise.

Bitter cold, ice and snow hampered the evacuation of the 160 passengers; all told, 45 lives were lost, including that of Captain Joseph Wood and all but one of the ship's officers. Imagine being jarred awake after a comfortable dinner outbound from New York City and essentially being thrown into freezing water or lifeboats. There was confusion, anger and fear, and even worse, many of the officers were killed during the tragedy, so safety directions were left up to the crew. The *Mohawk* sank within an hour. Nearby ships came to the rescue, and Coast Guard boats and planes searched through the night and the next day, first for survivors and then finally for bodies, as survivors could not manage in the freezing seawater for longer than a few hours.

The final disposition of the wreck was remanded to salvagers, who would use thousands of pounds of explosives to demolish the wreck. It was lying in the well-traveled shipping lanes, and the superstructure of her hull still protruded on the surface, even though the ship rested on the seafloor seventy

A brochure from the Clyde-Mallory Lines advertising the passage aboard the *Mohawk*, all for less than thirty dollars per passenger. *Author's collection.*

117

feet below. The wreck was blasted to allow for a depth of fifty feet of water above the wreck so as not to pose a navigational hazard in the heavily traveled shipping lane. Savage ships would wire-drag the wreckage to further cut it down. This process involved a heavy-gauge cable several inches thick secured to two ships, which would drag the wire through the wreck and, in effect, cut or saw it down.

Several factors combine to make the *Mohawk* one of the most dived wrecks in this area. Lying approximately eight miles directly east of Manasquan Inlet, it is in reasonably shallow water, with a depth of seventy feet, and it has a huge area of wreckage. Although it is nothing more than the barest outline of a ship, her hull still can be defined along her port and starboard side, but everything in between is just a jumble of twisted and broken metal—hardly anything resembles a ship anymore. It looks more like someone submerged a junkyard underwater, especially since much of the wreckage is truck and jeep parts. It's easy to get lost in the vast jumble of hull plates and twisted metal, so careful navigation is essential. Despite its popularity, this wreck still yields plenty of artifacts and lobster and offers many interesting sights for the observant diver.

The case for more stringent federal regulations was made when the passenger vessel *Mohawk* collided with the Norwegian motorship *Talisman*, killing forty-five people amid questions about whether modifications had been made but not inspected and whether mechanical components were not properly maintained.

In 1934, the 508-foot luxury liner *Morro Castle* burned at sea, killing 124 people. The ensuing investigation found many safety inconsistencies concerning the vessel's firefighting equipment and further discovered that the crew had not received proper firefighting training. Less than five months later in 1935, in response to these accidents, Congress passed more maritime safety legislation between 1936 and 1937 than it had during the previous twenty years. Congress would now regulate three categories regarding passenger vessel safety:

1. All passenger ship structure, modifications, equipment and material contained or used in the operation of such a vessel would need to be inspected and any modifications approved by the supervising federal agency.

2. It would define the number of officers and crew necessary to safely operate a vessel.

3. The federal government would supervise the merchant marine.

Moreover, this new legislation required that all marine casualties involving regulated vessels be reported and investigated. The Act of May 27, 1936,

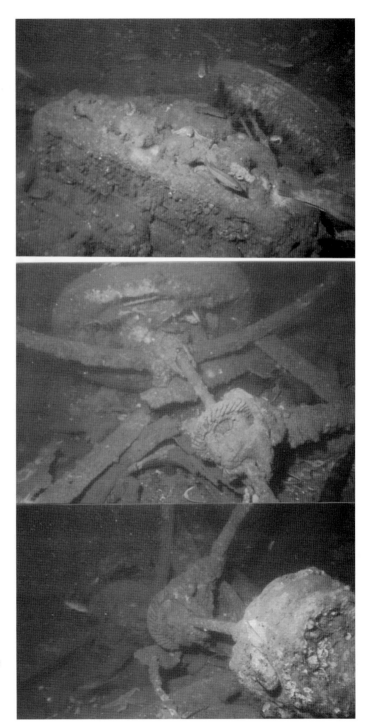

It is interesting to find chrome hubcaps and bumpers from cars of the era underwater—they don't make them much any longer! *Rich Galiano of NJScuba.net.*

Ocean pouts and frilled anemones are the new residents of the wreck. *Larry Cohen, www. liquidimagesuw.com.*

(Public Law 622) reorganized and renamed the Bureau of Navigation and Steamboat Inspection as the Bureau of Marine Inspection and Navigation (BMIN) (49 Stat. L. 1380). The bureau remained within the Commerce Department. It continued to enforce the laws and regulations of its predecessor agency. However, the 1936 act authorized the creation of a marine casualty investigation board and prescribed rules and regulations to investigate accidents on any United States waterway. From then on, inspections would be mandatory for all vessels that carried passengers for hire. Any modifications would require competent pre-planning by marine architects. Safety training and regularly inspected safety and navigational equipment was now mandatory, including lifesaving drills. The responsibility for managing all of these rules would ultimately go to the United States Coast Guard.

All of this is a result of these incidents. It is interesting and yet somewhat troublesome when you realize that it took so many thousands of lives and hundreds—if not thousands—of ships lost to reach this point. How many people would have lived had lifesaving efforts been made more of national priority and lifesaving stations positioned every few miles along deserted beaches back in the early nineteenth century?

Chapter 9

FIRE!

THE MORRO CASTLE

Fire! It is the most feared problem aboard any ship. Why? Depending on where it happens, it can shut down access to or even destroy whole systems. It complicates safety and confuses people. People have a visceral fear of fire and all the horrible things that happen because of it. Being trapped in a shipboard fire is any mariner's worse nightmare—and with good reason.

Two of the most horrendous maritime accidents were a result of fire. The *Morro Castle* and the *General Slocum* were two different types of ships from two different eras with the same terrible outcome. Much has been written about the *Morro Castle*, including many books. The story is compelling as much for the drama as for the conflicting accounts and the mystery that remains unsolved for over eighty years. The theories range from personnel ineptitude and corporate greed to spies and saboteurs, insurance fraud and government cover-ups. Perhaps all are related. Each rumor has a bit of substance to it but not enough to prove anything.

The ship's radio operator is credited with sending out the first SOS message. This was soon followed by a second, which announced that fire was blazing beneath the wireless room and concluded with the ominous words, "We can't hold out much longer." Thereafter, no further word came from the *Morro Castle*. The same operator is also considered the arsonist who set the fires. A few people have put forth theories they say support the conspiracy that the radio operator, George Rogers, who was hailed a hero might now be revealed as a psychopath, liar and murderer. Evidence, they

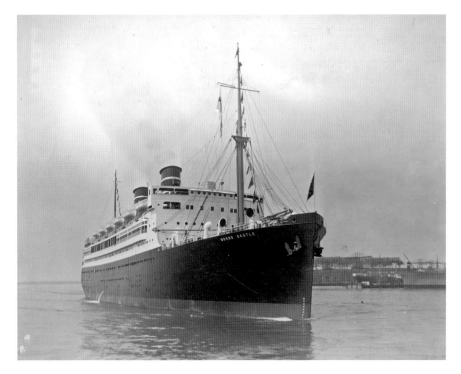

The *Morro Castle* in better days. She was part of the Ward Line. *Mariners Museum.*

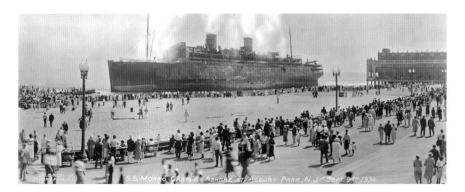

The *Morro Castle* became quite the tourist attraction in the late summer of 1934. *Mariners Museum.*

say, proves Rogers was not the dependable radio operator who stayed by his post trying to raise a signal from another ship. He was a pyromaniac who, through his extraordinary knowledge of explosives and radio devices, managed to take down a large liner. They show that, quite possibly, Rogers was also responsible for the untimely passing of the ship's captain, who died mysteriously, apparently poisoned, several hours later. This accident, along with that of the SS *Mohawk* a few months in the future, would put the Ward Lines of New York out of business. Perhaps the company saw this coming. There was and still is a lot of speculation and uncertainty. Choose a side and you can probably find evidence to support your claim or theory. Who's to say at this point who has the correct explanation or whether any will be found?

On September 8, 1934, early in the morning, the passenger liner *Morro Castle* was a few hours out of the New York Harbor on a return voyage from Havana. This was a normal run for this ship and cruise line. She was carrying 316 passengers and 230 officers and crew members. The ship's captain, Robert Willmott, wasn't feeling well and elected to take his dinner privately in his cabin rather than circulate among the passengers. He took ill and later died. The ship's doctor termed it to be severe stomach pains or perhaps a heart attack. Chief Officer William Warms assumed command. The captain's death was the first problem that led to many others. Some suggested he was poisoned, saying this was part of a grand scheme, whatever that might be. No evidence has been presented to support this accusation.

Regardless of this particular mystery, a fire broke out in the reading room or library. The fire spread quickly. The ship was a luxury liner, and ornate wood panels lined corridors and rooms. Fresh paint was everywhere to spruce up the ship, though some say it was more to hide the shortcomings of regular maintenance. The paint and solvents stored nearby added to the flames, as did safety equipment stored in a room above where the fire started. The fires spread very quickly, leading to speculation that there had been multiple fires in different parts of the ship. The weather indicated a potential nor'easter was building, and the winds had reached thirty knots quickly, which would easily fan the flames, hampering rescue and fire-fighting efforts. But the terrible swiftness with which the fires spread transformed the luxury liner into an inferno. The heavy toll of casualties was due partly to the extraordinary speed with which the fire engulfed the liner. Flames swept through the interior of the ship, filling the companionways and cutting off staircases before any word of warning could be carried to sleeping passengers. Those passengers on the upper deck could escape to boats or vacate their rooms

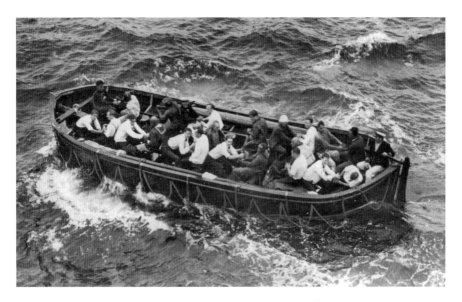

Survivors escaping in a lifeboat from the fire spreading aboard the ship. *Mariners Museum.*

easiest. People were starting to die horribly because they couldn't escape their decks or cabins. Lifeboat procedure was totally unorganized or even managed by the crew. Many lifeboats were launched with fewer passengers than their capacity or not at all—some supposedly with just crew, panicking and trying to escape. Panic and pandemonium were the words now, and like *Titanic*, frightened passengers who feared being burned by the fire jumped off ship in attempts to save themselves, adding to the confusion and carnage.

Many people died that night, and everyone wondered whether it was an accident or sabotage. Lots of unanswered and embarrassing questions were raised during the investigation following the disaster and never satisfactorily answered. Why was a proper alarm never given? Why did the fire-fighting equipment, such as it was, fail to function? A small number of the crew members tried to put out the fire while at the same time telling two young ladies who wanted to sound the alarm to be quiet lest they wake other passengers. Was this even true? Why weren't all the lifeboats launched? Only six to eight of twelve lifeboats were lowered, and why were they filled with crew and officers instead of passengers?

Both officers and crew were paralyzed with fear and indecision, and the result was a fire that quickly engulfed the ship. That's not so unexpected, as no one wanted to die, but officers and crew were supposed act above fear.

One account by Antonio Giorgio, an oiler aboard ship who was brought ashore in a boat at Spring Lake, New Jersey, told of "a bedlam of fighting men." He was resting in the petty officers' room after a spell of duty that had ended at midnight when he was awakened by screams and found the room filled with smoke. He opened the door and found flames everywhere. "Three times," he said, "I started upstairs, and three times my legs were grabbed and I was dragged down as men fought like beasts to get up a narrow ladder stairway."

No order was given to stop or turn the *Morro Castle* around. Consequently, the blaze burned everything back through the stern in quick order. Although only a few fire hydrants were used, water pressure became extremely low. In flames, the ship proceeded out of control up the coast. Panic ensued among passengers and crew members. Many of the crew looked out for themselves as they dropped lifeboats and filled them. They did not direct terrified passengers who had received no life vests or lifeboat drills at sea. Although the ship had more than enough lifeboats, they were not filled. Some of the lifeboats were literally painted in place and could not be lowered. More afraid of being burned to death than being in the water, many people jumped into the Atlantic Ocean. No

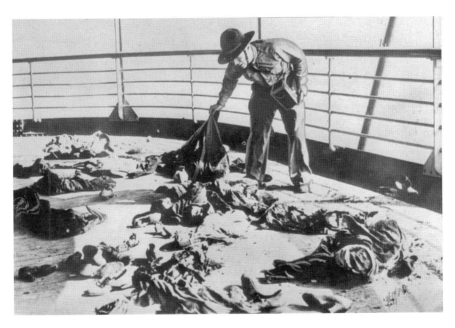

Officers searching the decks for personal identification and effects of victims and survivors. *Mariners Museum.*

one was told that cork life preservers needed to be held upon descent or they could cause injuries such as broken necks or unconsciousness, and this added to the fatalities. Ships and local boats from the coastal Asbury Park area headed to the scene, rescuing a number of people in the water. Others had died from their fall, were crushed by the ship's propellers or drowned during a night of high seas and bad weather.

The death toll was heartbreaking: a total of 137 people died. Survivors told of their rescues. Miss Una Cullen said that she was having cocktails with three friends in the lounge about 4:00 am. They saw smoke but were told by stewards not to worry; the fire would be put out easily. They went out to see what was going on, and "suddenly fire just jumped at us." Miss Cullen said she went below, awakened her roommate and got a coat and a life-preserver. She tripped going down a rope ladder and fell into the sea. She was in the water seven hours, she thought. While she was waiting to be rescued, she saw the mother of one of her friends suddenly let go and drown. Mrs. Edward Brady, wife of a physicist, related that she had the tragic experience of seeing her husband die of exhaustion after he had kept up alongside her for seven hours in the ocean. She tried to hold him up, but with the last of his strength he pushed her off and told her to save herself. She was rescued a few minutes later.

Investigations took place after the ship had beached itself off the oceanfront Convention Hall at the summer resort of Asbury Park. The FBI, under the direction of J. Edgar Hoover, conducted inquiries into the tragedy, as did every level of government. Testimony was confusing, conflicted and self-serving in cases. The *Morro Castle* became an oddly morbid tourist attraction and would be visited by thousands of tourists until mid-March the following year. First, they saw the smoldering hull, which became, days and weeks later, a charred remains. Summer businesses extended their season well into the fall, making for the best season they had in years. Souvenirs were sold, and hotels, boardinghouses and restaurants did a brisk business until the hulk was towed away for salvage. People would come and just stare at the wreck, perhaps envisioning what it had been like, grateful they weren't there. All of this happened during the Great Depression; so many of the people watching probably couldn't have afforded the passage anyway. What would any of us think as we watched and pondered the reason for so many deaths?

GENERAL SLOCUM

A discussion about the greatest sea disasters has to include the *General Slocum*. Similar to what happened on the *Morro Castle*, a shipboard fire overtook this vessel so quickly and completely and left nothing but death in its wake. The loss of life on the *Slocum* was so great as to be compared to the *Titanic*, which was seven years in the future, yet this story is nowhere near as well known. The tragedy occurred in New York City, but it has a final New Jersey connection.

On Wednesday, June 15, 1904, the *General Slocum* was chartered by the St. Mark's Evangelical Lutheran Church for $350, and the ship carried 1,358 passengers, plus crew members. The passengers came mostly from the German-American community of the Lower East Side, although many members of the Jewish-American community were also aboard. Everyone was excited, with families and friends enjoying a break from the routines of their daily lives with this joyous excursion. It was going to be a grand day, the weather was comfortable and there was lots of gaiety along the decks as

The *General Slocum* was built in Brooklyn and her engines constructed in Hoboken. *Author's collection.*

mothers and children ran about, looking forward to their day cruise along the North Shore of Long Island.

The ship pulled away from the dock and was working her way up the East River, but that happiness would turn to terror very soon. The accounts vary about how the fire started, but survivors agree it spread quickly. Within a half hour of leaving the pier near Ninetieth Street, the fire spread. The panic had to be horrific among the passengers as they faced death by drowning or being burned alive on the ship. Since the passengers were mainly immigrants, they probably could not swim—especially the children—and the clothing of the day did not help them. Most of the passengers were women or mothers and their children.

The old wooden ship burned fiercely from bow to stern, and the situation worsened through negligence and incompetence on the part of the owners, the captain and crew. In just minutes, the *General Slocum* burned to the waterline. Over 1,000 people, mostly women and children, died in the flames or drowned in the swift currents of Hell Gate. Entire families perished, and a community of German immigrants was destroyed, leaving just grieving husbands and fathers, many of whom subsequently took their own lives. For days afterward, bodies would wash ashore. Only 321 survived from a total of 1,344 passengers. The final death count totaled 1,021. The next largest

General Slocum notecard. *Author's collection.*

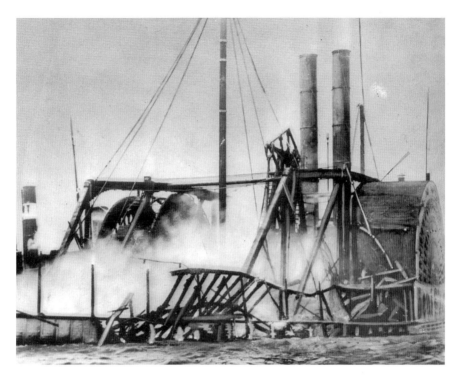

General Slocum burning. *Mariners Museum.*

death toll for such a disaster in New York would occur at the World Trade Center, where 2,974 civilians died in an act of terrorism.

There would be miracle stories of survivors for the lucky few and heartbreak for those who lost loved ones. Eyewitnesses from the shore could see the boat burning and wondered why the captain did not come to shore. The captain had opportunities to put the ship near the shore, but inexplicably he did not attempt this. It was widely reported that Captain William Henry Van Schaick would not bring the ship to shore for insurance reasons. Testimony that would follow in the days ahead established that there were few safeguards; life vests were rotten or, worse, stuffed with lead weights in order for them to pass inspection reviews. The lifeboats were in the same state, fire drills were nonexistent and the crew was untrained to handle the panic that followed on board the *Slocum*. Quickly, Van Schaick and the Knickerbocker Steamboat Company came under the crosshairs of an investigation. Frank A. Barnaby, the president of the company, defended the actions of the captain and the crew, but Captain

Van Schaick would be convicted by a jury. He was found guilty of criminal negligence because he had failed to maintain the fire drills required by law and was sentenced to ten years at hard labor. And what happened to the Knickerbocker Steamboat Company and Frank Barnaby, who owned the ship? Nothing—in fact, Barnaby tried to sue to limit the amount of money his company would have to pay in damages. Captain Van Schaick would serve only part of his sentence at Sing Sing prison. He received a pardon (through the efforts of his wife) from President William Howard Taft in 1911.

What is the New Jersey connection? The remains of the ship, even though it had burned to the waterline, were salvaged and rebuilt as a barge, rechristened the *Maryland*. The *Maryland* would sink three more times before she was finally abandoned. The wreck was rediscovered with reasonable certainty beneath several feet of sand off Corson's Inlet between Sea Isle City and Stone Harbor by author Clive Cussler. The coal barge *Maryland* sank in heavy weather with no casualties—an utterly forgettable occurrence, were it not for the hulk's previous existence as the side-wheel excursion steamer *General Slocum*.

THE NEW SHIPWRECKS

ARTIFICIAL REEFS

Artificial reefs are places where wrecks are sunk intentionally. No storm, fires or collisions—here we use explosives and blowtorches. On one occasion, Navy Seals actually parachuted into the ocean, swam to the wreck, put explosive charges on it and sank it. How cool is that? Unfortunately, the navy never did that again.

In its place, members of the State Police Bomb Squad volunteered their services and over the years did a bang-up job (pardon the pun) helping sink ships on the reef. They are a great bunch of guys. I was lucky enough myself to help put a few of them on the bottom, earning a State of New Jersey Reef Recognition award in the process for my efforts sponsoring the reefs and helping Bill Figley and Jeff Carlson put them on the bottom. Mr. Figley was largely responsible for making the New Jersey reef system what it is today as one of the nation's largest and most comprehensive artificial reef systems in the United States with over fifteen reefs and 131 wrecks and many other materials like concrete and rock from demolished bridges or roadways; only the State of Florida has a bigger reef program. These artificial habitats were all paid for not with our tax dollars but with individual donations and fundraisers, as well as grants from recreational fishing groups. With a very limited budget, the reef program has depended on donations to cover the costs of cleaning and preparing ships and other materials for sinking on reefs.

Since 1984, the New Jersey Artificial Reef Program has constructed over one thousand reefs, including over one hundred vessels, on its network

Above: Bill Figley, former coordinator for the Artificial Reef Program in the Department of Fish & Game for the State of New Jersey, is pictured here looking over the sinking of the *McAllister* tug on the offshore Shark River Reef. *Author's collection.*

Left: The propeller and stern of the *Travis* tug sunk on the Sea Girt Artificial Reef. The tug, named after Travis Nagiewicz and built in 1920, is one of the oldest vessels sunk in New Jersey as a reef. © *Herb Segars, gotosnapshot.com.*

of fifteen ocean sites located from Sandy Hook to Cape May. Reefs are constructed from ships and barges, concrete demolition debris, dredge rock, concrete-ballasted tire units and a variety of other dense materials. Each item deposited on the site becomes its own reef. In that way, they are similar to coral reefs typically found in warmer southern waters. The largest coral reef in the world is the Great Barrier Reef of Australia, which can be seen from space and is over 3,000 kilometers long (1,800 miles) long.

These ships, rocks and even army tanks and subway cars are structures, and every underwater structure eventually provides habitat for marine life on a sea floor that has very little. This is the reason for developing artificial reefs. The continental shelf off New Jersey is pretty flat and reasonably barren in that there are no reefs. The sandy-muddy seafloor may have a few outcroppings of natural or glacial rocks, but there really aren't many places fish can find shelter or food, so we build reefs. To understand how the seafloor looks off New Jersey imagine a perfectly flat top of a pool table. Like the flat pool tabletop, there is little or no height or structure on the seafloor except for a few small sand ridges or depressions and maybe a few rock piles. There is very little structure for marine life to flourish, and fish need the structure to support the food chain and for habitat. If you have

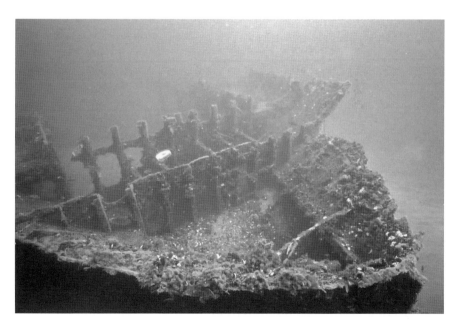

This is the wreck of the *Dykes*, which was a five-masted steel-hulled schooner. © *Herb Segars, gotosnapshot.com.*

seen images or video of coral reefs you see the structure they provide to attract small marine life (the bottom of the food chain) and hold more and bigger biodiversity of marine life. We build these artificial reefs because we found that when the fish become attracted to the reefs, we can catch them as fishermen or photograph them as divers. Collectively, all of the individual users of the reefs provide the State of New Jersey with about $1 billion of tourism revenue every year. There are more than 154,000 boats registered in New Jersey, about 1.5 percent of all the boats in the United States. All of these fifteen reef systems bring people to boat, scuba dive and fish, both recreationally and commercially.

New Jersey's Artificial Reef Program is one of the biggest and most successful of any, especially from a diver's perspective. In comparison with most other Atlantic Coast states, New Jersey has placed more vessels per person and per mile of coastline than any other. New Jersey's Artificial Reef Program has also placed millions of tons of rock and concrete rubble. Ships are usually donated, but money has to be found to clean the ships following rigorous environmental standards to ensure they will not pollute or harm the marine environment. Then they have to be towed out to a pre-selected reef site and sunk. Many of the supporters of the program do it to help and usually charge a nominal fee to cover the minimal costs. There is even an ancillary program where prisoners make concrete reef balls, which act as excellent reef structure. These domed structures are maybe six to eight feet across, weigh five hundred pounds and have many holes to allow fish and other marine life to live and thrive. Think of them as really big Wiffle ball halves.

The reefs are studied to determine how much biomass they support. The term "biomass" refers to the amount of marine life, from small microorganisms like phytoplankton to soft and hard corals to tautog (blackfish) sea bass and over four hundred different species of marine life. In addition, these reefs are regularly side scanned to determine if things have moved or been covered over or covered up. The seafloor is a fairly active place, changing all the time. One of the largest ships on the reef is the USS *Algol*, which was sunk on the Shark River Reef, the deepest reef off the coast. It is a former Liberty ship from World War II. This vessel, sunk in 1991, is over 400 feet long and once weighed in at thirteen thousand displacement tons. It is a big ship, yet a few years after she was sunk, a powerful nor'easter came through the area with seas so large they actually picked up the wreck, which had been imbedded or stuck into the seafloor, and moved it over 1,000 feet along the bottom to where she presently sits. That is evidence of the power to change the ocean

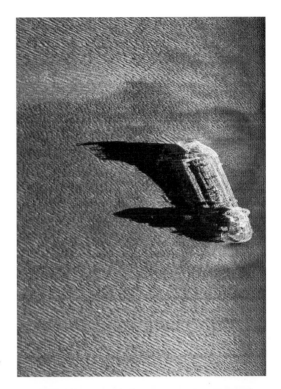

Right: A sonar image of a ship on the artificial reef off Atlantic City. You can clearly see the ripples in the sand. These ships provide needed habitat for marine life. *Vince Capone, Black laser Learning.*

Below: Olga Torry peers out the porthole opening on the *Venturo* tugboat on the Sea Girt Reef. *Larry Cohen, www.liquidimagesuw.com.*

An opening that once housed a porthole on the lower deck of the tugboat *Veronica* that is located on the Axel Carlson Artificial Reef. The wreck was sponsored by and named after Veronica Segars of Brick, New Jersey. © *Herb Segars, gotosnapshot.com.*

floor. The wreck has settled finally and is sinking very slowly. Through the process of scour from ocean currents, she digs herself a little deeper each year. A trip to the engine room used to be a 135-foot dive, but now with her sinking, it's more like 145 feet or perhaps deeper.

The Artificial Reef Program has lately come under scrutiny by politicians looking to appease commercial fishing interests, who want to utilize the reefs for their own livelihoods. A federal program that designates the money solely for recreational use funds the reef program. However, this being New Jersey, nothing is that simple. The story even made the *New York Times* in 2007. The paper featured the argument of who owns the reef with the story headline "Battleground of Rot and Rust." For a few years the program was halted as funding issues stopped. Recently, a compromise was reached allowing partial or dual use of a few reefs for commercial and recreational activities. No one is really happy with the compromise, but now reef building can at least restart. Eventually, new reefs will be added, and perhaps a reef will be created solely for commercial lobstermen.

The reefs are under a lot of stress, but so, too, are reefs in Delaware and other states. They were built for economic reasons: to make money for the people who use them for diving and fishing and for the state to collect sales revenue and taxes. Gas, tolls, hotels, restaurants, tackle, bait, diving equipment sales and rentals are all part of the tourism process before you get to catch a fish. This program is a win-win for everyone, especially the marine life that get brand-new habitat and the chance to try as hard as they can to avoid being caught.

Chapter 11

UNDERWATER SUBWAY

Steam Trains and Redbirds...All Aboard!

How about this for a mystery: how did two steam locomotives sitting side by side in ninety feet of water about eight miles off Asbury Park actually wind up on the seafloor? Captain Paul Hepler, diving off his charter dive boat *Venture III* in 1985, initially discovered the locomotives. NOAA's Office of Coast Survey marked the location in 1991 when it made a coastal survey of shipwrecks part of the Automated Wrecks and Obstructions Information System (AWIOS) list. The real mystery is how did they get there, and who owned them? Finding these answers would be easier if the locomotives could be dated to a specific time of construction. With that information, one could research manufacture and shipping records and trace ships and/or storm events in the area. Historical research doesn't mention such loss. No insurance company—at least based on research made thus far—has paid out a claim for two missing trains. There is no evidence of a ship or barge buried in the sand underneath them, although the locomotives do appear to sit on iron grating or platform of some type, which makes sense if they were shipped on a barge or ship. There aren't any shipwrecks nearby that might have dropped them. Did they fall off a ship, and if they did, how did they land side by side and right side up? Might they have been pushed off to save the ship from a storm, or did they actually fall off in a storm? As with any mystery, there are lots of questions and speculation but, right now, few answers that make any sense.

We do know they are unique examples of early steam locomotives. The wheel arrangement is one way of identifying the type of engine

and when it was built. These locomotives have a unique 2-2-2-wheel layout. Under the Whyte notation (named for the man who devised this way of characterizing steam locomotives, Frederick Methvan Whyte) for the classification of steam locomotives, 2-2-2 represents the wheel arrangement of two leading wheels on one axle, two powered driving wheels on one axle and two trailing wheels on one axle. The wheel arrangement both provided more stability and enabled a larger firebox. The first of these locomotives showed up in England in 1834 named as the Pioneer Series. It was the habit to name the engine types similar to naming system for types or classes of ships.

The *Jenny Lind* locomotive, named after a famous opera singer of the time, was the first of a class of ten steam locomotives built in 1847 for the London Brighton and South Coast Railway by E.B. Wilson and Company of Leeds. The design proved successful, manufacturers adopted it for use on other railways and it became the first mass-produced locomotive type. The *Jenny Lind* type was also widely copied from the late 1840s into the 1860s. Experts think these particular examples were probably constructed in the early 1850s, possibly by the Seth Wilmarth Union Works, a South Boston builder of locomotives from 1848 until 1855.

In comments made in a September 2004 article in the *Philadelphia Inquirer,* several train experts weighed in on the find of these unusual locomotives:

"It's a real archeological find—there are only a handful from that era that still exist," said David Dunn, director of the Railroad Museum of Pennsylvania. The six-wheeled engines are among the earliest American workhorse locomotives, designed during "an era when these machines were considered the space shuttles of the mid-19th century." Jim Wilke, a railroad historian who lives in Los Angeles, said, "These engines are extremely rare." The Smithsonian Institution, for example, owns a similar one, the Pioneer. And a somewhat smaller, slightly younger, eight-wheeled steam engine, the People's Railway No. 3, is on display at the Franklin Institute in Philadelphia, Pennsylvania. John H. White, a former railroad curator for the Smithsonian, described the discovery of the two steam engines near New Jersey as "unusual, an oddity." "We don't have much from the 1850s. These are new pieces that were unknown."

The steam locomotives interested the New Jersey Historical Divers Association. The wreck site is now protected by Federal Notice to keep divers from removing what may be historical artifacts, and when all these

Above: A drive wheel on a steam locomotive. The locomotives date from the 1850s. The locomotives have a 2-2-2-wheel layout, which was rare in the Americas. *Herb Segars, gotosnapshot.com.*

Right: A front view of a steam locomotive. The Seth Wilmarth Union Works in South Boston might possibly have built these locomotives. © *Herb Segars, gotosnapshot.com.*

The steam engine or locomotive at Allaire State Park in Wall, New Jersey. This is a later example of what the steam engines off Asbury Park might have resembled. *Author's collection.*

questions have answers, these locomotives may become part of a National Heritage Landmark Site.

From locomotives to subway cars—only in New Jersey, right? The seafloor of New Jersey is home to shipwrecks of all types, but the idea of using subway cars as artificial reefs originated from the New York City's Metropolitan Transit Authority. New York City Transit's legendary Redbirds made their farewell journey on Monday, November 3, 2003, on the Flushing Line between Times Square and Willets Point. Their track would be forever changed to one that took them underwater and offshore New Jersey and other states. Their riders would no longer be only commuters; now they would serve marine life and fishermen way above on the surface, along with the occasional scuba diver. They now have a new economic value. The Redbirds got their name from the color of the sides of the cars, painted deep red to stop the graffiti that was a constant issue. They were old, and newer, more efficient cars were ordered. Only 1,400 of them existed, and someone thought it would be a great idea to use them as reef material.

However, not everyone thought it was a great idea. Instead, it created quite an environmental uproar. Many environmentalists thought the asbestos in the cars would create an ecological problem and, at the same time, send the wrong message about what can be used for reef-building material. New Jersey ordered six hundred of these cars—only to put that on hold as this environmental concern was worked through. The first subway cars were placed on reef in the state of Delaware, then South Carolina, Georgia and Virginia, before finally New Jersey accepted some for the Shark River Reef, located sixteen miles off Shark River Inlet in Belmar.

The Shark River subway cars were the last of 250 donated by the New York Metropolitan Transportation Authority (MTA) and were dropped into the sea at five locations off the Jersey coast from July to October in 2003. The deployment came after three years of wrangling in the press and committee hearings between fishermen and environmentalists. The cars would help bolster the recreational fishing business, which adds considerable revenue to the state's billion-dollar fishing business, not to mention the connection to the state's tourism business.

The Bronx Redbirds subway cars were donated by the New York City Transit Department, which is of course a subsidiary of the Metropolitan Transit Authority (MTA). *Author's collection.*

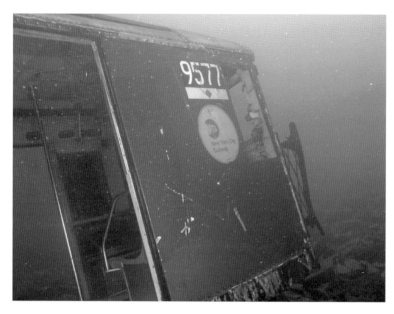

Above: One of the subway cars up close. Notice the rocks and rubble in the background, also placed on the reef as building material and future home to marine life. *Rich Galiano of NJScuba.net.*

Below: Inside the car, looking out. Looks like there is no problem commuting down here! *Rich Galiano of NJScuba.net.*

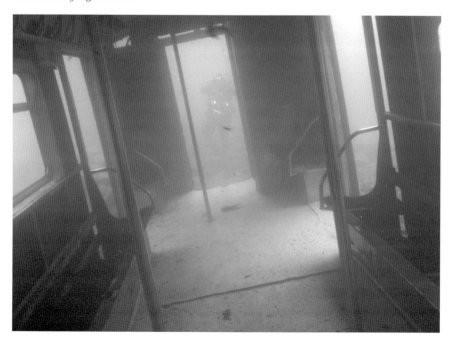

The MTA paid the entire freight for cleaning the cars and carting them offshore to be piled onto the mounds of rocks, cement chunks, obsolete military tanks and purposely sunken ships that make up New Jersey's artificial reefs. The cars—with their wheels taken off, their windows and seats extracted, their oil drained and their graffiti gone but their straps and asbestos floor tiles still in place—were piled two high on the barge. In a news article for the *Record*, writer Bob Ivry noted, "A bucket loader straight out of Bob the Builder pulled the cars one by one to the edge of the barge and nudged them, like toys, in a cloud of rust dust, off the side."

Whichever side of the argument you fall on, you must admit subway cars are a strange addition to the state's maritime heritage.

Chapter 12

SHARK!

FIRST RECORDED ATTACK IN HISTORY

Yell "SHARK," and everyone gets out of the water. Where did fear that begin? When did we start fearing sharks and why? There are two events that come to mind that started that fear. The first was, of course, the movie *Jaws*, released in 1975 but based on the book by written by Princeton, New Jersey native Peter Benchley in 1974. The film would have a profound impact on people's fears of going swimming in the ocean and the fears of dangers that we can't see underwater. *Jaws* was the prototype summer blockbuster movie. People lined up around the block to see it at theaters, and the film changed the way we looked at sharks and sparked an interest in them—especially in great white sharks—that still exists today. Some say that people's fear of being attacked by a shark had a hand in what shark advocates call the indiscriminate killing of these ocean predators that is still going on so many years after the film's release. Benchley, who wrote the book and the movie screenplay, did so with good research and intentions and made a lot of money from it—justifiably so. It was an excellent story, verbally and visually. Later in life, he would come to regret the impact it had because our fear resulted in the destruction of sharks.

The movie was based on a real shark attack scenario that many people may not have heard about. This shark attack happened a long time ago in the summer of 1916 along the Jersey Shore and coincidentally, it was briefly mentioned in the film version of *Jaws*. If a movie could scare so many people into fearing sharks, then a very real shark attack would paralyze beach-goers for a summer back in 1916. It is the story of the first recorded shark attack

A great white shark. *Amos Nachoum, www.biganimals.com.*

in history written into the book *The 12 Days of Terror in 1916* by Richard M. Fernicola, MD, a New Jersey resident and local historian of note.

There was a lot going in our country at the time of 1916. World War I was beginning, and the Battle of Verdun involved over two million soldiers and was perhaps the bloodiest of battles. Brooklyn lost the World Series, the National Parks Service was formed and approved by Congress and the government budget was less than $1 billion. It would be another year before New Jersey beach-goers would worry about enemy submarines destroying ships off the beaches. The beaches were the place to cool off in the ocean to stave off the oppressive heat of summer and take some time to relax and forget worries. But on July 1, 1916, the ocean would become something to fear.

The tale begins in Beach Haven, where a young student named Charles E. Vansant, a resident of Beach Haven, was bitten and later died of injuries from a shark attack. He was pulled from the shallow water along the beach, bleeding profusely, but could not be saved. It was a "freak attack," people said. Five days later, while swimming in the surf line, probably off where he worked at the Essex and Sussex Hotel in Spring Lake, bellboy Charles Bruder would become the second fatality. He was swimming out beyond

where his friends were when he was heard screaming, "A shark bit me! Bit my legs off!" These are the last words Charles would ever speak. Protective mesh barriers went up almost immediately around swimming areas. Still, it was too late to save the rest of the tourist season. What would happen next would elevate the panic to a new level.

The town of Matawan is nowhere near the ocean. In fact, you would have to drive for fifteen or twenty minutes to find the ocean beach of Sandy Hook, but the Raritan Bay empties into the ocean and Matawan has a few creeks that empty into the bay. Residents hearing about the attacks still felt safe here. After all, they were in fresh water and a long way away from the shark attacks they had read about off a Spring Lake beach. Swimmers would often use Matawan Creek, a narrow creek that wound its way to the bay. Captain Thomas Cattrall was walking home after a good day of fishing. When he crossed over Matawan's drawbridge, he noticed something that seemed almost impossible: a huge shark was heading up the inland waterway. He was confident that what he saw was very real, and so he tried to warn everyone who'd listen. Though the citizens were all aware of the two shark attacks on the coast, no one could really believe there was any great threat

Face-to-face with Jaws. The great white shark is a beautiful and powerful animal. *Amos Nachoum, www.biganimals.com.*

of an attack in a small body of fresh water. The captain's story was ignored. Who would believe that fish tale?

On July 12, a factory across town was generously letting eleven-year-old Lester Stillwell leave work a little early. This was well before Child Labor Laws were passed, if you were wondering how an eleven-year-old was let out of work. After meeting some friends, they went for a swim in the Matawan Creek. While they splashed and played, Lester told his two friends, both only a few feet away, to watch him floating on his back. A moment later, he was violently pulled beneath the water. His friends watched in horror as he bobbed up and down, screaming when he broke the surface. Blood filled the water around him as the shark dragged him under again and again. His friends swam as fast as they could and then ran into town screaming and crying. Victim number three had died violently and horribly in the most unlikely location.

Twenty-four-year-old Stanley Fischer sped to the creek with two other men thinking that Lester may have suffered an epileptic seizure. The two men dove in, not knowing there was a shark still attacking the boy's corpse. Stanley Fischer attempted to pull the bloody body away from the shark and was also attacked. He died a few hours later at Monmouth Hospital in Long Branch as the fourth victim. The shark wasn't done yet, heading back down the stream toward the bay, where it struck again within one hour of the last attack, wounding twelve-year-old Joseph Dunn, who only narrowly escaped with his life but lost a leg. He would be the fifth and final victim.

Was a rogue shark or a school of sharks responsible? Was it a bull shark or a great white shark? Was the shark's motivation hunger or fear? Residents took this matter in their own hands, looking for revenge on the animal that could do this. Like the scene in the movie *Jaws* with all the men in town going out to catch and kill the Amity shark, the greatest shark hunt in the state's history was underway. Although no one knew the species or its size, retribution would be massive. Hundreds of sharks were caught and slaughtered. Eventually, a great white shark was caught, and there was some reported evidence that human remains were found in its stomach, although that was never confirmed. Experts seem to agree the shark in 1916 would've been a bull shark, as they can easily adapt to saltwater and freshwater conditions, attack unprovoked and are proven man-eaters.

Fast-forward to 2014–15, when schoolchildren and the news media eagerly followed the story of Mary Lee. The shark is one of more than one hundred sharks around the world being tracked by OCEARCH, a nonprofit organization dedicated to shark research. In early 2015, the shark was offshore Seaside

Heights and the Lavallette area, swimming within two miles of the shoreline. The shark was spotted traveling between Ocean and Atlantic Counties. As the organization's research has grown, so has the number of people who are following each of its tagged sharks on social media sites. As the *Ocean City Patch* newspaper reports, "Mary Lee, however, has taken on a following of her own, complete with a Twitter audience of nearly sixteen thousand followers. "@MaryLeeShark Can I petttttt youuuuu? Come to Middletown!" tweeted one follower, to which the shark's account replied, "Just a little too creepy for me, Jordan." Mary Lee is 3,456 pounds and sixteen feet long and has traveled almost twenty thousand miles since she was first tagged off Cape Cod in September 2012, according to OCEARCH.

But why is Mary Lee in New Jersey? Experts are unsure. They still don't understand the migration patterns of great white sharks. Mary Lee could be swimming to a "nursery area" to give birth or could just be following seals to Cape Cod. There is an area off the Jersey coast where historically many white sharks migrate to give birth, the executive director of the Shark Research Institute in Princeton, Marie Levine, told NJ Advance Media previously. To protect sharks from poachers, she wouldn't give the exact location.

The shark attacks of 1916 seem forever far away as you read this. On one hand, I'm happy that people are reversing their thoughts about sharks as enemies. They are not our enemies; they just happen to be the apex predator and an integral part of the ocean's food web. As the chairman of the board of Shark Research, my organization works hard to conserve sharks and educate children and adults why sharks are important and necessary. On the other hand, I wonder what the people from 1916 New Jersey who lived with the attacks would think of sixteen thousand school kids who excitedly track the shark as if she were a pet. Shark attacks are emotional, visceral events that attract attention, but your chance of being killed in a bicycle accident is greater than by shark attack. In 2009, there were 630 deaths due to bicycle accident and only one shark-related death. Yet the shark attack still makes the front page. Somewhere in the back of our minds, the DNA memory of 1916 is still there.

Chapter 13

SUPER STORMS AND
CHANGING COASTLINES

Perfect examples of changing coastlines can be found on antique maps and charts. Collecting them is an addicting hobby. They are difficult to find; many are reproductions and all are expensive. But they give a unique "photograph" of history, depicting what the state of New Jersey looked like, in this case, over 182 years ago. On the following page, you see a cropped image of an old map dated from 1833, courtesy of the Office of Coast Survey. The map shows the towns and settlement in the state at that time as well as the inlets.

It is interesting to note how different the shore appears on the 1833 map compared to what we have along the coastline today. Ocean currents and prevailing winds stay reasonably constant in their directions over the years, and by examining maps like this, we can see the impact storms have made. One of the coastline-shaping ocean currents is called longshore current and is the primary reason sand is being pushed up the coast toward Sandy Hook, making it longer. Perhaps you have noticed the groins or piles of rock on the beaches, often mistakenly referred to incorrectly as jetties; jetties line the two sides of an inlet. The process of longshore current takes sand from one side of these beach groins and transports it up or down the New Jersey coast. As the sand moves along the rock groins, it forms a scalloped edge until it can travel past the tip or end of the groin and continue its journey. You can usually tell which direction the ocean current is moving by the amount of sand on the side of each groin. The Army Corp of Engineers installed these groins to slow the flow of sand off the beaches, which form a protective barrier against storm winds and waves, which are all part of beach erosion.

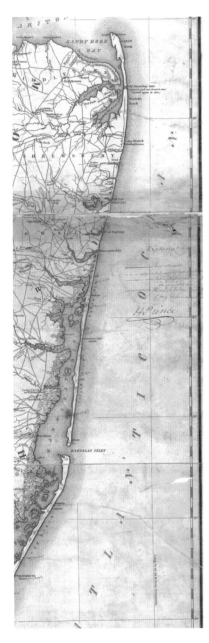

The 1833 Coastline of Central New Jersey from Sandy Hook to Barnegat Bay. This old map shows the inlets along the shore, some open then but closed today due to changing ocean currents and powerful storms. *NOAA's Office of Coast Survey.*

The 1833 map shows the inlets the sea had opened prior to the printing. Shrewsbury inlet opened in 1778, closed in 1810 and reopened again in 1830. Farther down the coast, just below the town of Long Branch, Whale Pond shows up as an inlet, while a little farther south in the town of Deal it is open to the ocean. Between the towns of Deal and Avon, Little Pond is an inlet, and it seems Long Pond is also open to the sea. Deep Creek, located just above Shark River Inlet, is also open to the ocean. Traveling farther to the south, Wreck Pond is an inlet and has been open and closed a few times in history, and there is another unidentified inlet a mile or so north. There was no name attached on this map, so perhaps it was too small to make further mention. Cranberry Inlet is closed but has opened and closed a few time before. Finally, there is Barnegat Inlet, which itself has stayed open over the centuries, but its depths vary constantly by shifting sands, and it requires good local knowledge to operate a vessel safely in and out of the inlet.

This is what hurricanes and nor'easters do. Of course, it's not that simple, but it is part of how our coastline gets shaped. Fierce storms bring winds, tidal flooding and waves to move sands and open or close these inlets. After looking over so many old maps, you see a pattern of openings and closings in the same places—almost as if the sea remembers the susceptible places.

Powerful storms that travel up the United States coast do great damage quickly and dramatically, and there is a human cost as well as an economic one. Over the past 150 years, New Jersey has experienced many tropical storms, hurricanes and nor'easters. Hurricanes form as a result of warm water, which provides the fuel to develop a hurricane. How? Well, as the warm, moist air evaporates, it moves upward, higher into the atmosphere, and as this happens, it creates low pressure at the surface. Like a vacuum, it is sucking up warm air, drawing it away. As the low-pressure area develops, the entire process develops a spin, which can cause an eye to form and a hurricane to be born. Hurricanes travel quickly, and they expend their energy once they hit colder waters and land. That doesn't mean they are over, however. It just means the storms are losing energy, and their rotation will move them along a path governed by air currents and the earth's rotation by something called the Coriolis Effect. The key to the Coriolis Effect lies in the earth's rotation. The earth rotates faster at the equator than it does at the poles. This is because the earth is wider at the equator; this is the fattest part of the planet. A point on the equator has farther to travel in a day.

For example, let's pretend you're standing at the equator and you want to throw a ball to your friend in the middle of North America (and you have a really strong arm!). If you throw the ball in a straight line, it will appear to land to the right of your friend because he's moving slower and has not caught up.

Now, let's pretend you're standing at the North Pole. When you throw the ball to your friend, still waiting to catch the ball in North America, it will again appear to land to the right of him. But this time, it's because he's moving faster than you are and has moved ahead of the ball.

This apparent deflection is the Coriolis effect. The wind is like the ball. It appears to bend to the right in the Northern Hemisphere. In the Southern Hemisphere, winds appear to bend to the left.

In the Northern Hemisphere, wind from high-pressure systems pass low-pressure systems on the right. This causes the system to swirl counter-clockwise. Low-pressure systems usually bring storms. This means that hurricanes and other storms swirl counter-clockwise in the Northern Hemisphere. In the Southern Hemisphere, storms swirl clockwise.

Nor'easters are winter and spring's most violent storms and usually happen anytime between September and April. A nor'easter is a storm that mainly affects the northeastern part of the United States. These storms form along the East Coast as warm air from over the Gulf of Mexico or the Atlantic Ocean clashes with arctic cold to the north and west. A nor'easter gets its

name from the northeasterly winds that blow in from the ocean ahead of the storm. Typically, around three to five nor'easters impact the United States a year, according to AccuWeather.com. For example, a hurricane may only have a thirty-mile radius of a strong wind field around the center, while a nor'easter may have a one-hundred-mile radius of a strong wind field from the center. A nor'easter can even come on the heels of a hurricane. In October 2012, in the wake of Hurricane Sandy, a nor'easter rattled the East Coast, where it dampened efforts to restore power and aid victims.

The Great Blizzard of March 1888 was ushered in by a powerful nor'easter. This storm settled over New York, New Jersey, Massachusetts and Connecticut for two days and dropped up to fifty inches (127 centimeters)

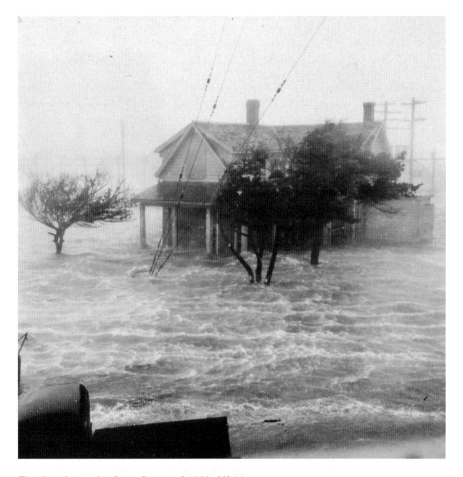

Flooding due to the Great Storm of 1962. *NOAA.*

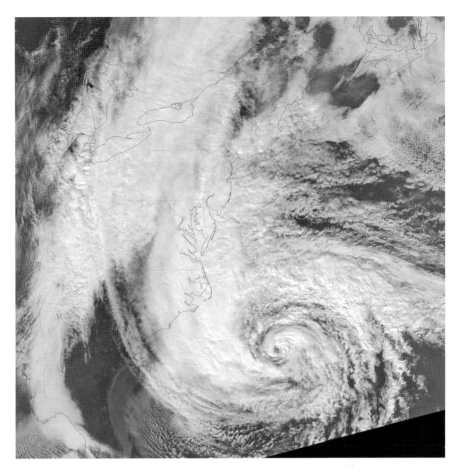

A NASA satellite image of Hurricane Sandy, with the East Coast in outline. There are several weather systems in play here, making Sandy the "Superstorm" it was. *NASA.*

of snow. The nor'easter provided plenty of moisture and strong winds that fueled the blizzard. The unseasonably late storm literally buried about half of its four hundred victims in snowdrifts that piled up between downtown buildings. It snapped telegraph poles. It shut down rail lines and trapped passengers in rail cars for days. And in the months that followed, the storm did something else, too. It prompted New York City's officials to design and build an extensive subway system. It also led to buried telegraph and electrical lines. While that was a good decision at the time, after Superstorm Sandy, it caused a minor disaster as flooding shorted out those electrical lines and systems and destroyed that underground infrastructure.

So why give the weather lesson? Weather shapes our lives in more ways than just our decisions about what to wear or complaints about ruining our vacations. Superstorm Sandy really impacted our lives; it created billions of dollars of damage—much of which is still left to be rebuilt—and discussions about changing where and how we should rebuild for the future, just as that storm of 1888 did.

It is almost definite that we will get another big storm; the only question is when. It's hard to say. Looking back on recorded storms over two hundred years, they seem to happen every three to five years. If you believe that storms are affected by global climate change, then we may get fewer of them in number but stronger, more powerful ones. Fifty years ago, we knew little about the Pacific Ocean currents called El Niño and La Niña. They impact us very much, but let's hold off on that for another book.

Have you ever heard mention of one-hundred-year storms, two-hundred-year storms, five-hundred-year storms or one-thousand-year storms? Many people think they refer to how often one will happen or repeat. Let's take the extreme, a one-thousand-year storm. It won't happen once every one thousand years. It refers to the chance of one happening every year. So a one-thousand-year storm has a .01 percent chance of happening every year. That's better than your chance of winning the lottery, but it's still a real long shot. Yes, it generally means it will be a powerful storm—you've heard of Superstorm Sandy, right? Many factors come into play to create such a storm, much as they did for Superstorm Sandy. At the bottom end is a one-hundred-year storm, which has a 1 percent chance of hitting every year. One chance in one hundred are pretty good odds but still low probability. Depending on whom you believe, Superstorm Sandy was between a five-hundred-year and seven-hundred-year storm. Thank you to Weather Underground and Climate Central for your explanations.

The World Meteorological Organization develops a list of names that are assigned in alphabetical order to tropical storms as they are discovered in each hurricane season. Names can be repeated after an interval of six years, but the names of especially severe storms are permanently retired from use. Twenty-nine hurricane names have been retired in the last fifteen years. You are safe from any tropical storm or hurricane named Steve until at least after 2017. In 2011, there were fourteen severe weather events—the most in U.S. history. They included tornadoes, drought, wildfires, flooding, snowstorms/blizzards, one tropical storm and a hurricane. It cost us over $56 billion in damages and killed 675 people.

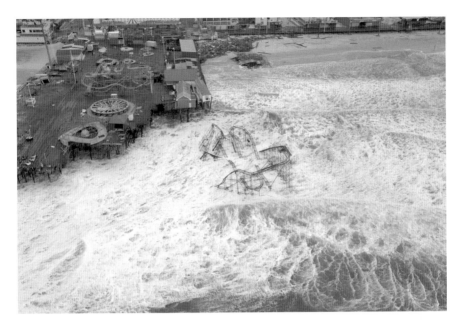

An iconic image of the impact that Superstorm Sandy had along the New Jersey coast. Here is the amusement pier in Seaside. *NOAA*.

Let us not forget that the stories told here in this book are almost all a direct result of severe weather. We are better at forecasting these events now, but we are not immune from being on the receiving end of them. Hopefully we can be better prepared and safer.

Chapter 14

FINAL NOTES

With so many events and shipwrecks off the 127 miles of coastline off New Jersey, new revelations will always be possible, and research with high technology, like side-scan sonar and scuba diving, will no doubt be the instrument of discovery. Yet discovery happens when someone reads a story or looks through old family memories or letters and starts asking questions. There are still thousands of mysteries buried under the beaches, in our bays and rivers and especially under the sea. Included below are some curious additions to the many wrecks that lie on the ocean floor.

Weird NJ once wrote about the mystery of the United States Air Force losing two hydrogen bombs one hundred miles off the Atlantic City coast in 1957. The Cold War was at its height, and both superpowers would compete for who had the most nuclear devices or atomic bombs. A C-124 Globemaster cargo plane had taken off from Dover Air Force Base on a classified transatlantic mission carrying three nuclear bombs each, which had no nuclear core (uranium or plutonium material necessary for the nuclear reaction), but the plane did carry one nuclear core. (The air force never specified how the nuclear cores of the bombs were transported aboard flights such as this one.) The C-124 experienced flight problems almost immediately, and its crew faced a decision of trying to return to base, crash into the ocean or make another base. They weren't sure the effect of crashing or dropping the bombs. The plane was going to crash unless they could gain altitude, so the crew decided to jettison the very heavy hydrogen bombs they carried aboard, thinking that losing this

Operation Crossroads Baker nuclear bomb test. *United States Department of Defense photo.*

An air force photo of a thermonuclear bomb. *National Museum of the Air Force Museum.*

weight might allow them to make Atlantic City Naval Air Station. One by one, the crew jettisoned two of the bombs, which apparently crashed into the ocean without exploding. Fortunately, they didn't contain their nuclear cores, but they were packed with enough conventional explosives to cause serious damage, and of course, they were highly classified. They didn't need to jettison the third bomb or the nuclear core, and the plane landed safely at Atlantic City Naval Air Station.

As for the two bombs that were dropped, were they actually ever recovered or was it all labeled as "top secret," covered up or forgotten? No one knows, or they aren't telling. These two bombs are still lost offshore of Atlantic City. Perhaps they are, as reported, filled with only conventional explosives and not a nuclear core, but did we get the true

story? They apparently did carry one nuclear core. There are many questions and no clear answers.

An Internet search provided some insight. Since 1950, there have been thirty-two nuclear weapon accidents, known as "Broken Arrows." A Broken Arrow is defined as an unexpected event involving nuclear weapons that result in the accidental launching, firing, detonating, theft or loss of the weapon. To date, six nuclear weapons have been lost and never recovered. One would think that if they were that classified and dangerous, we might take better care of them.

USS *AKRON*

The navy lost one its airships off the New Jersey coast, the USS *Akron*. The airships were designed for long-range scouting in support of fleet operations. Often referred to as flying aircraft carriers, the helium-inflated airships carried F9C-2 Curtiss Sparrow hawk biplanes, which could be launched and recovered in flight, greatly extending the range over which the *Akron* could scout the open ocean for enemy vessels.

USS *Akron* departed Naval Air Station (NAS) Lakehurst on the evening of April 3, 1933, on a mission to calibrate radio direction–finding equipment along the northeastern coast of the United States. The ship was under the command of Frank C. McCord, and among the seventy-six persons on board were VIPs including Rear Admiral William Moffett, chief of the Navy's Bureau of Aeronautics, and Commander Frederick T. Berry, commanding officer of NAS Lakehurst. Shortly after midnight, in the early minutes of April 4, the ship was hit by a series of strong updrafts and downdrafts off the New Jersey coast. Akron rose and fell in the strong winds, and while attempting to climb, the ship's tail struck the water. With its control surfaces destroyed, *Akron* was lost, and the ship crashed into the ocean.

The crash of the *Akron* caused an appalling loss of life, and of the seventy-six persons on the ship, only three survived: two sailors and the ship's executive officer, Herbert Wiley. The rest of the ship's passengers and crew died in the ocean from exposure to the frigid water, compounded by the lack of any lifejackets to keep survivors afloat. The airship's location has always been a matter of interest. Finding the exact location will probably never happen. The girders that provided the skeleton for the airship would have long along ago eroded or became buried in

Airship the USS *Akron* under construction. *Mariners Museum.*

shifting sands. Best-selling author Clive Cussler even got involved with his nonprofit shipwreck organization NUMA, named for the fictional organization in his novels.

TEXAS TOWER 4

Built in 1957, the five Texas Towers were intended to become part of the USA's advanced early warning system against Soviet bombers. Named for their resemblance to oil platforms found in the Gulf of Mexico, the towers were radar platforms designed to be placed out to sea. Towers 1 and 5 were never built. Towers 2 and 3 were situated on the rocky seabed off Nantucket and Boston, respectively. Tower 4 posed a much greater challenge, as it needed to be placed in waters twice as deep and on a soft bed of sand and mud. The men who manned it sarcastically referred to it as "old shaky" not only for its stability on the soft sandy seafloor but

also because it was battered by several storms and hurricanes. Thinking about this system today, a radar platform sixty miles offshore wasn't going to give any of us that much early warning, and almost as soon as they were built, the Texas Towers had been rendered obsolete by the advent of Soviet long-range missiles. I can remember practicing air raid drills in school as a kid and being told to hide under my school desk—as if that was going protect me from a nuclear fireball. But this was at a time when nuclear tensions were high.

On January 15, 1961, the U.S. Coast Guard raced through the darkness toward a tiny point eighty-four miles southeast of New York City. There, twenty-eight crew members of Texas Tower 4 were waiting desperately to be evacuated from their station. Thirty-five-foot waves, huge swells and eighty-mile-per-hour winds were pounding the platform, and the Coast Guard

Deep-water shipwrecks (150- to 250-foot depths) present many difficulties for scuba divers. *Larry Cohen/Olga Torry, www.liquidimagesuw.com.*

A close-up of the myriad types of marine life that inhabit the wrecks off New Jersey. © *Herb Segars, gotosnapshot.com.*

radios continually picked up a frantic transmissions from the tower: "We're breaking up." And with that, Texas Tower 4 and all of its fourteen airmen and fourteen civilians were killed as the ocean swallowed up the ill-fated tower seventy-eight miles off the Barnegat Light. When the rescue ships arrived, just one body was pulled from the water. The remaining twenty-seven had been dragged to the bottom with the remains of Old Shaky.

The wreck of Tower 4 rests under more than 180 feet of frigid water, inhabited now by sharks, dolphins, turtles and the occasional visiting scuba diver. In 1999, a plaque was fixed to the submerged leg of the tower. It lists the names of the twenty-eight victims who perished on that cold January night.

I hope you have enjoyed the stories presented in this book and have come away with a better understanding of the maritime history of New Jersey and how the shipwrecks and tragedies—terrible though they were—have helped make traveling our oceans safer. My own experience of diving has helped me appreciate each of their stories and history and helps me and others identify many shipwrecks. It has also made me personally connected to how lifesaving rules have evolved, been redefined and been applied for the safety

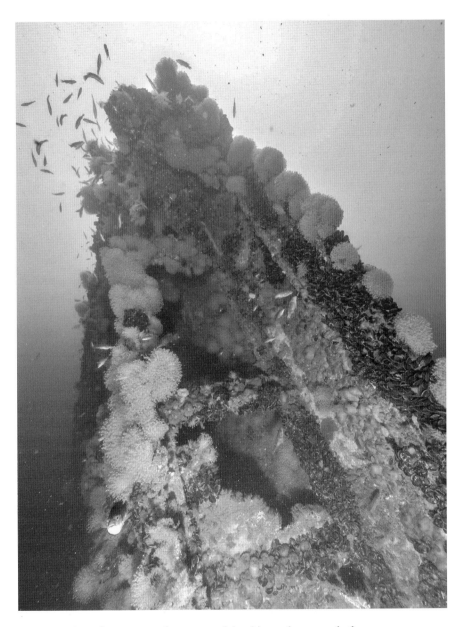

Life abounds on these oases underwater, and the shipwrecks are partly the reason so many species of fish are found off our coast. *Olga Torry, www.liquidimagesuw.com.*

of passengers and ships' crews. I have operated a dive charter boat for several years, and my vessel was subject to those safety rules and regulations, whose origins lies with the stories of shipwrecks like the *Ayrshire*, the *New Era*, *John Minturn*, the *Morro Castle* and the SS *Mohawk*, whose stories helped re-shape how we looked after safety. I am sure that the people who perished on these shipwrecks can at least rest a little easier knowing that their lives will now help save others and, more importantly, that we will always remember them in these continuing stories of maritime history that lie forever off the New Jersey Coast.

BIBLIOGRAPHY

Books

Bennett, Robert F. *The Life-Saving Service at Sandy Hook: 1854–1915*. Washington, D.C.: U.S. Coast Guard Historical Monograph Program, 1976.

Berman, Bruce. *Encyclopedia of American Shipwrecks*. Boston, MA: Mariners Press, 1973.

Botting, Douglas. *The Giant Airships*. Richmond, VA: Time Life Book, 1981.

Brockmann, John R. *Exploding Steamboats, Senate Debates, and Technical Reports: The Convergence of Technology, Politics and Rhetoric in the Steamboat Bill of 1838*. Amityville, NY: Baywood Publishing Company, Inc., 2002.

Buchholz, Margaret Thomas. *Shipwrecks of New Jersey*. Harvey Cedars, NJ: Down the Shore Publishing Corp, 2004.

Burton, Hal. *The* Morro Castle. New York: Viking Press, 1973.

Capuzzo, Michael. *Close to Shore: The Terrifying Shark Attacks of 1916*. New York: Broadway Books, 2001.

Coyle, Gretchen, F., and Deborah C. Whitcraft. *Inferno at Sea: Stories of Death and Survival Aboard the* Morro Castle. Harvey Cedars, NJ: Down the Shore Publishing, 2012.

Cunningham, John T. *The New Jersey Shore*. New Brunswick, NJ: Rutgers University Press, 1958.

Davis, Bill. *Shipwrecks of the Atlantic*: *Montauk to Cape May*. Point Pleasant, NJ: The Fisherman Library, 1991.

Downey, Leland Woolley. *Broken Spars: New Jersey Coast Shipwrecks, 1640–1945*. Bricktown, NJ: Brick Township Historical Society, 1983.

Fernicola, Richard E. *12 Days of Terror*. Guilford, CT: Lyons Press, 2001.

Figley, William, Jeff Carlson, and Barry Preim. *The Shipwrecks of the New Jersey Reefs*. Trenton, NJ: Artificial Reef Association, 2003.

Figley, William, Barry Priem, and Steve Perrone. *A Guide to Fishing and Diving New Jersey's Artificial Reefs*. Trenton: New Jersey Dept of Environmental Protection, Bureau of Marine Fisheries, 1989.

Gannon, Michael. *Operation Drumbeat*. Annapolis, MD: Naval Institute Press; Reprint edition, March 2009.

Gentile, Gary. *Shipwrecks of New Jersey*. Norwalk, CT: Sea Sport Publications, 1988.

Heston, Alfred M. *South Jersey, A History, 1664–1924*. New York: Lewis Historical Co., 1924.

Kemp, Frank. *Nest of Rebel Pirates*. Egg Harbor Township, NJ: Batsto Citizens Committee, 1966.

Koedel, Craig R. *South Jersey Heritage: A Social, Economic and Cultural History*. Mays Landing, NJ: University Press of America, 1979.

Krotee, Walter, and Richard Krotee. *Shipwrecks off the New Jersey Coast*. Philadelphia, PA: Underwater Society of America, 1965.

Lamberton, Karen T. *Angels in the Gate: New York City and the* General Slocum *Disaster*. Berwyn Heights, MD: Heritage Books, Inc., 2006.

Lloyd, John Bailey. *Eighteen Miles of History on Long Beach Island*. Harvey Cedars, NJ: Down the Shore Publishing/The SandPaper, 1994.

Ludlum, David, M. *The New Jersey Weather Book*. New Brunswick, NJ: Rutgers University Press, 1983.

Morris, Paul, C. *American Sailing Coasters of the North Atlantic*. Chardon, OH: Bonanza Books, 1979.

Moss, George H., Jr. *Nauvoo to the Hook*. Sea Bright, NJ: Ploughshare Press, 1991.

O'Donnell, Edward T. *Ship Ablaze: The Tragedy of the Steamboat* General Slocum. New York: Broadway Books, 2004.

Pierce, Arthur D. *Iron in the Pines*. New Brunswick, NJ: Rutgers University Press, 1957.

Proceedings of the Literary and Philosophical Society of Liverpool, during the 71st Session 1881–82. D. Marples & Co, Liverpool, England 1882.

Quinn, William P. *Shipwrecks Along the Atlantic Coast*. Orleans, MA: Parnassus Imprints, 1988.

Rattray, Jeanette, E. *Perils of the Port of New York*. New York: Dodd Mead. 1973.

Sachse, Julius Friedrich. *The Wreck of the Ship New Era*. Lancaster, PA: Pennsylvania-German Society, 1907.

Savadove, Larry, and Margaret Buchholz. *Great Storms of the New Jersey Shore*. Harvey Cedars, NJ: Down the Shore Publishing/SandPaper, 1993.

Shanks, Ralph, Wick York and Lisa Woo Shanks. *The U.S. Lifesaving Service: Heroes. Rescues and Architecture of the Early Coast Guard.* Novato, CA: Costano Book, 1996.

Short, Lloyd, M. *Steamboat-Inspection Service its History, Activities and Organization.* New York: D. Appleton and Company, 1922.

Siebold, David, and Charles J. Adams. *Shipwrecks Near Barnegat Light.* Barnegat Light, NJ: Exeter House Books, 1984.

Thomas, Lowell, *Raiders of the Deep.* London: William Heinnemann, 1941.

United States Life Saving Service. *Annual Report of the Operations of the United States Life-Saving Service.* Washington, D.C.: United States Life Saving Service, 1875–1915.

Veasy, David. *Guarding New Jersey's Lighthouse and Life-Saving Stations.* Charleston, SC: Arcadia Publishing, 2000.

Wilson, Rufus Rockwell. *The Sea Rovers.* New York: B.W. Dodge and Company, 1906.

Articles, Papers and Manuscripts

Abbot, Jacobs. "Some Account of Francis Life-Boats and Life-Cars." *Harper's New Monthly Magazine,* July 1891.

Act of February 28, 1871: 16 Stat. 458. The creation of the Steamboat Inspection Service.

Appletons' Journal, Literature, Science and Art 13 (January 2–June 26, 1875).

Beloe, Charles, M. Inst. "The Life-Saving Service of the United States of America." *American Life Car.*

Bennett, Robert, CDR USCG. "A Case of Calculated Mischief." *Naval Institute Proceedings Magazine* 102/3/877 (March 1976).

"A Bill to Create the Coast Guard by Combining Therein the Existing Life-Saving Service and Revenue Cutter Service." U.S. Senate Bill 2337, May 1913.

Capron, Walter C. *The U.S. Coast Guard (The Watts Sea Power Library Series).* New York: Franklin Watts, 1965.

Colimore, Edward. "Shipwreck from 1860 off Atlantic City to Become Historic Site." *Philadelphia Inquirer,* April 2014.

Department of the Treasury, Annual Report, 1854.

"Explosions of Steamboat Boilers." Twenty-Second Congress, Second Session, May 19, 1832.

Figley, Bill. "The Condition of Subway Cars Sunk on the Sea Girt Reef Site." *Nacote Creek (NJ) White Paper*, June 2004.

Fleeson, Lucinda. "Mound of Evidence: A Heap of Oyster Shells May Provide Archaeologists with a Valuable Record of How Man Lived in New Jersey in Prehistoric Times." *Philadelphia Inquirer*, April 1995.

Fulmer, John H. "The Wreck of the *New Era*: Analysis of Events Leading to the Deaths of Approximately 255 German Immigrants on the New Jersey Coast." Historical research paper, 1965.

Hanley, Robert. "Diving to Prove Indians Lived on Continental Shelf." *New York Times*, July 2003.

Lieb, Theresa. "The *New Era* Anchor." *NJHDA Journal* 6, no. 1 (2002).

"The Life Savers for Those in Peril on the Sea." *Naval Institute Proceedings Magazine* 102/3/877 (March 1976).

"Loss of the Sindia." *Along the Coast*, August 1909.

Merryman, J.H. "The United States Live-Saving Service." *Scribner's Monthly*, January 1880.

Merwin, Daria, PhD. "The Potential for Submerged Prehistoric Archaeological Sites off Sandy Hook." *Bulletin of the Archaeological Society of New Jersey* 57 (2003).

Moore, Kirk. "Subway Cars Dumped into Water for Artificial Reef." *Asbury Park (NJ) Press*, October 2003.

Morro Castle and Mohawk Investigations. Preliminary Report of the Committee on Commerce pursuant to S. Res. 7 (74th Congress), March 17, 1937. Government Printing Office, Washington, D.C.

Motor Boat Act of 1910: Public Law 61-201 36 Stat. 462.

Motor Boat Act of 1940: Public Law 76-484, 54 Stat. 163.

Moulton, Warren R. "Rescue at Sea, Morro Castle." *The New Republic* 80, October 31, 1934.

Nagiewicz, Stephen D. "New Jersey's Top Ten Shipwrecks." *Nor'easter Magazine*, September 1983.

———. "NUMA." *Skin Diver Magazine*, November 1984.

Newell, William A. "Rescue at Sea." *New Republic*, October 1934

———. Senate Committee on Commerce, Letter from the Secretary of the Treasury, Transmitting Report of the General Superintendent of the Life-Saving Service Relative to the Claims of W.A. Newell as the Originator of the System of the Life-Saving Service of the United States (hereafter cited as Newell Letter), 55th Cong., 2d sess., 1898.

———. Testimony to Senate Committee on Commerce. "Remarks Delivered on a Proposition to Devise Means for the Preservation of Life and Property from Wrecks on the New Jersey Coast." 1848.

Newman, Andy. "Battlegrounds of Rot and Rust." *New York Times*, September 2007.

New York Daily Times. "Terrible Shipwreck and Loss of Life! Wreck of the Ship New Era of Bremen." November 14–16, 1854.

———. "Terrible Shipwrecks. Great Loss of Life." April 20–22, 1854.

Records of the Bureau of Marine Inspection and Navigation, National Archives. "The Steamboat Inspection Service and the History of Merchant Vessel Inspection." 41.3.2 Records of the Second Supervising District (New York, NY) Field Records of the Steamboat Inspection Service. 1845–1955.

Snyderman, Marty. "Peter Benchley Talks About Diving and the Deep." *Skin Diver Magazine*, May 1985.

The Steamboat Act of August 30, 1852: 10 Stat. 61. U.S. Steamboat Inspection Service

Symmes, Patrick. "The Ghost of Shipwreck Future." *Outside Magazine*, April 2002.

U.S. Coast Guard. "An Historical Overview of Passenger Ship Disasters and Casualties: Report of the Cruise Ship Safety Review Task Force." October 31, 1995.

"Vessels Wrecked by Winter Gales." *Along the Coast*, May 1909.

Voulgaris, Barbara. *From Steamboat Inspection Service to U.S. Coast Guard: Marine Safety in the United States from 1838–1946*. United States Coast Guard, 2009.

Periodicals and Newspapers

Various editions of the following periodicals and newspapers:

Asbury Park (NJ) Press, Asbury Park, NJ.

Atlantic Magazine, New York, NY.

Harpers New Monthly Magazine, New York, NY.

Monthly Nautical Magazine, Quarterly Review, New York, NY.

New York Times, New York, NY.

Philadelphia Inquirer, Philadelphia, PA.

Press of Atlantic City, Atlantic City, NJ.

Specific editions:

Asbury Park Press, August 2014 and November 2014

Monthly Nautical Magazine Volumes 1854–55

New York Times, April 1854, November 1854 and November 1988

Philadelphia Inquirer, December 1996, September 2004 and August 2014
Press of Atlantic City, July 2014

Research Libraries and Museums

Atlantic City Historical Association, Part of the Atlantic City Public Library
Library of Congress, Washington, D.C.
Mariners Museum, Newport News, VA
Monmouth County Historical Association
National Archives, Washington, D.C.
New Jersey Historical Divers Association, Wall, NJ
New Jersey Maritime Museum, Beach Haven, NJ
New York Public Library Archives
Ocean City Historical Museum
Ocean County Historical Society
Ocean County Library
Point Pleasant Historical Society, Point Pleasant Beach, NJ
State Museum of Pennsylvania at Harrisburg, PA

Internet Resources

Americanhistory.si.edu/onthewater
Gendisasters.com
Geo.hunter.cuny.edu
Historyplace.com
history.navy.mil
Libraries.rutgers.edu/rul/libs/scua
Nauticalcharts.noaa.gov
Ncdc.noaa.govPhotolib.noaa.gov
NJscuba.net
Radomes.org/museum
State.nj.us/nj/about/history
State.nj.us/dep/njgs
statemuseumpa.org/
TheShipsList.com
Uboat.net
Uscg.mil/history

BIBLIOGRAPHY

USGS.gov
Weather.gov
Weatherunderground.com/history
WeirdNJ.com
WHO.int
Wikapedia.com

About the Author

Captain Steve is a former dive charter boat operator and acknowledged authority on shipwrecks and scuba diving. He has written about or has been profiled about his knowledge of shipwrecks in many regional and national publications. Nagiewicz is fellow and former executive director of the Explorers Club, former facility manager for the State of New Jersey's Marine Science Laboratory at Sandy Hook and domestic sales manager for Diving Unlimited International. He is chairman of the board of trustees of the Shark Research Institute of Princeton, New Jersey. Steve Nagiewicz is co-expedition leader of the recent *R.J. Walker* Shipwreck Mapping Expedition off Atlantic City. He is the former owner of NJScuba.net and is a licensed USCG master and professional diver, with over four thousand scuba dives. He currently teaches environmental and marine science in high school and college. He lives in Brick, New Jersey, with his wife and son.